IMAGES
of America

SAN JOSE'S
JAPANTOWN

IMAGES
of America

SAN JOSE'S
JAPANTOWN

James Nagareda

ARCADIA
PUBLISHING

Published by Arcadia Publishing
Charleston, South Carolina

Printed in the United States of America

Library of Congress Control Number: 2016955714

For all general information, please contact Arcadia Publishing:
Telephone 843-853-2070
Fax 843-853-0044
E-mail sales@arcadiapublishing.com
For customer service and orders:
Toll-Free 1-888-313-2665

Visit us on the Internet at www.arcadiapublishing.com

*This book is dedicated to my family, friends, and the Issei
and Nisei that paved the way for us to have a better life.*

CONTENTS

ACKNOWLEDGMENTS

Over 15 years ago, my friend Curt Fukuda contacted me, and we began a project of capturing the history of San Jose Japantown. During this process, we picked up a few other people: Janice Oda, Ralph Pearce, June Hayashi, and Ward Shimizu. Together, we were able to collect hundreds of interviews and photographs that were compiled into a comprehensive book called *San Jose Japantown—A Journey*.

Using some of the material collected for that book, I was able to dig deeper into the history of this area. It seemed to me that people were more open to the idea of sharing their stories and precious family photographs after seeing our first publication.

A special thank you to Steve Fugita, Curt Fukuda, Roy and PJ Hirabayashi, Reiko Iwanaga, Japanese American Museum of San Jose, Leon Kimura, Richard Kogura, Gordon Koo, Norman Mineta, Jimbos, Joanne Mock, Nagareda Studio, Eric Nakagawa, Nikkei Traditions–San Jose, Janice Oda, Ralph Pearce, Carole Rast, Rast family, San Jose Taiko, Jean Shimoguchi, Rev. Jay Shinseiki, Sandy Wong, Jimi Yamaichi, Gene and Jo Ann Yoneda, and Pam Yoshida.

INTRODUCTION

San Jose's Japantown started on the very edge of the city in the late 1800s. Under suspicious circumstances, Chinatown suffered a devastating fire in 1887 and moved from downtown San Jose to property owned by John Heinlen, south of Taylor Street, between Sixth Street and Seventh Street. This area would eventually become known as Heinlenville. By the 1890s, Japanese migrant workers started to arrive in the Santa Clara Valley with the hope of finding work in the growing agricultural industry. The Japanese found their way to Heinlenville and ended up staying in the area due to the familiarity of being near an established Asian community. Heinlenville would eventually be demolished in 1931 after the Heinlen estate went bankrupt, and the city seized his property.

With the increasing number of Japanese arriving, it was only a matter of time before they started to open their own businesses on Jackson Street and on Fifth Street. In the early 1900s, these businesses catered to the mostly young, Japanese bachelors that came to work in agriculture. Many of the Japanese men that were the first to immigrate to the United States were trying to avoid being drafted or they were not the "first son," who would inherit the family wealth.

Due to anti-Japanese sentiment and to slow down the number of male immigrants, the United States and Japan came to a gentleman's agreement in 1907. Japan agreed not to issue passports to people wanting to work in the United States, and the United States agreed to accept the wives and family of those already living here. This agreement would shift the composition of the area to a more "family-friendly" environment and contribute to the formation of Japantown.

In the following years, there would be increased development in Japantown, and this would continue until 1942. Churches, grocery and general stores, hotels, restaurants, and more would be in operation until the passage of Executive Order 9066 during World War II, which forced the Japanese Americans on the West Coast to be interned to remote areas in the interior of the United States. Many families lost their property and businesses.

After several years of internment, people returned to Japantown and started to rebuild their lives. Many that were involved in agriculture before the war, chose to pursue new careers during a time when anti-Japanese sentiment was still prevalent.

The community endured and Japantown saw significant growth during the 1950s through the 1960s. During this time, you could stop in Japantown and take care of all of your daily needs. Grocery stores, restaurants, barbers, pharmacies, service stations, doctors, and dentists were all open during that time.

The 1970s and early 1980s were a time of cultural awareness and activism. This was a critical time for Japantown's long-term survival, because this led the way for redevelopment in the late 1980s through the 2000s.

Throughout the history of San Jose's Japantown, there have been the expected ups and downs. The community lived with *gaman*, which means it remained "resilient and persistent." The true story of Japantown's longevity is a story of the people that make up the community. Today, San

Jose's Japantown is one of three remaining Japantowns in California, while prewar, there were 46. San Jose's Japantown also has the distinction of being the only surviving Japantown that has remained in its original location. Japantown remains a vital and lively community, full of tradition and *gaman*.

One

BEGINNINGS

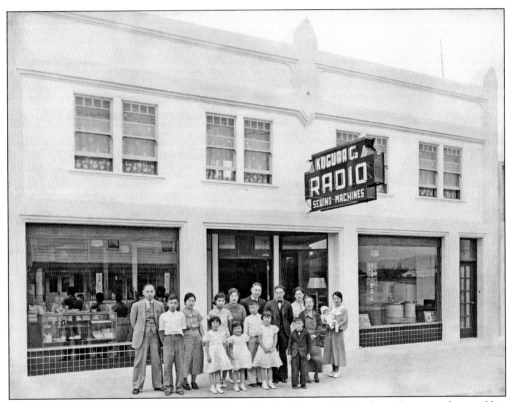

On February 24, 1934, Kohei Kogura purchased the building at 231 Jackson Street and moved his store from its former location at 616 North Sixth Street. Although Fukumatsu Yamatoda passed away in 1924, his family poses in front of Kogura Company in 1936. From left to right are Kohei Kogura, Tadao Kogura, Hatsuyo Yamatoda Kogura, Bernice Nakagawa Akizuki, Kazuko Kumamoto Kogura, Hanako Okamura Yamatoda, Chiye Takeda Kogura, James Kogura, Shigeru Yamatoda, Akiko Yoshioka Kogura, Tsutomo Akizuki, Edward Akizuki, Matsuko Yamatoda, Ohato Iwamuro Yamatoda, and Jane Yamanaka Yamatoda. (Courtesy of Richard Kogura.)

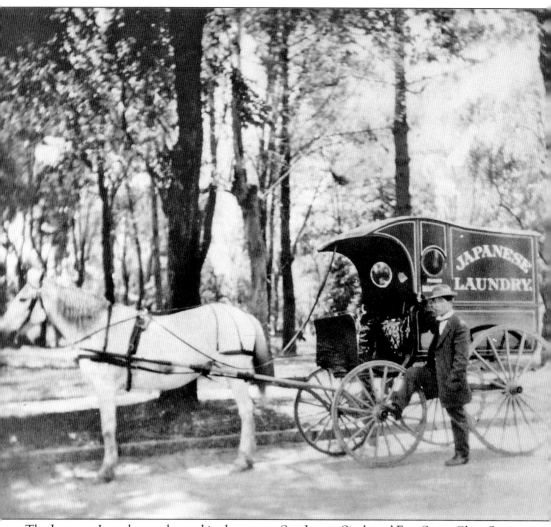

The Japanese Laundry was located in downtown San Jose at Sixth and East Santa Clara Street. Opened in 1902 by Jizaemon Akahoshi, Saburo Hioki, and Ichimatsu Tsurukawa, they used this horse and buggy for pick-ups and deliveries. Akahoshi poses for this photograph. Their business benefitted from a rumor that the Chinese laundries would use spit to steam iron their clothes. (Courtesy of Reiko Iwanaga.)

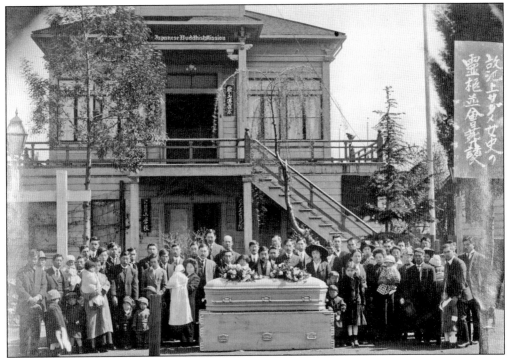

Many old photographs were taken after funeral services. This could have been due to the costs or availability. This photograph from the early 20th century was taken in front of the Japanese Buddhist Mission on North Fifth Street. This is the original building where the front stairs went to the side. Notice the two hitching posts located near the bottom of the photograph. (Courtesy of Japanese American Museum of San Jose.)

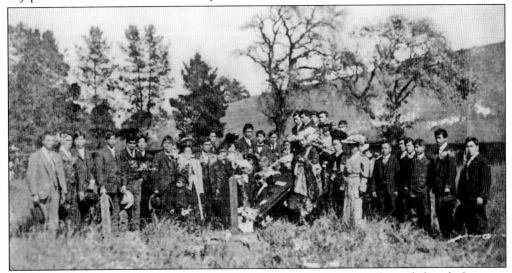

Oak Hill Cemetery is located a few miles from Japantown and remains a favored place for Japanese families to bury their loved ones. In this photograph from April 1908, Rev. Honen Takahashi presides over a funeral service in the "Japanese section" of the cemetery. Takahashi was the first resident minister at San Jose Buddhist Church from 1906 to 1915. (Kanemoto Collection, courtesy of K. Kawahara.)

Photographs were taken of funeral processions and attendees to send to relatives in Japan that could not attend the service. It was important to show distant relatives that their loved ones were given a proper funeral. This photograph was taken in the early 1900s in front of 231 Jackson Street. (Photograph by Ishino Studio, courtesy of Higuchi family.)

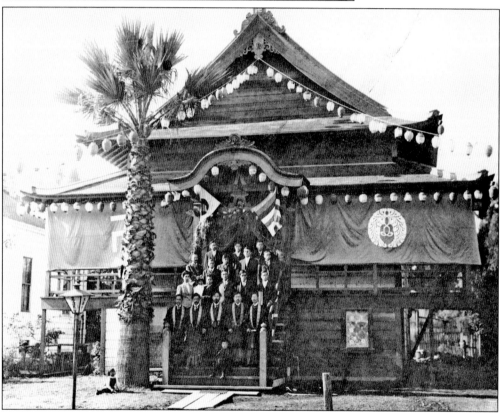

The Maku cloth on the front of the San Jose Hongwanji Buddhist Church at 523 North Sixth Street is only used when there is a special religious ceremony. The beautiful building was a house renovated by the Nishiura Brothers Construction Company in 1911 and was only used for 26 short years. This photograph was taken in 1920. The building was torn down after the mid-1930s, with the lot remaining vacant for many years until homes were finally built on the property. Historians Curt Fukuda and Ralph Pearce speculated that the building might have been torn down so that the lumber could be used in the construction of the new church on Fifth Street. (Courtesy of K. Kawasaki.)

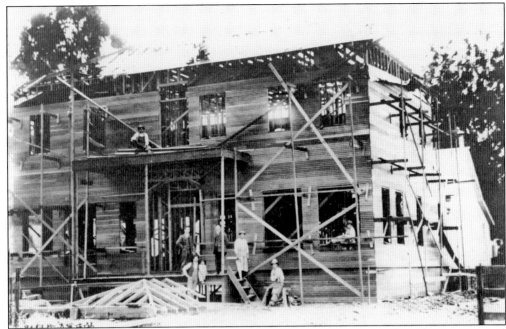

In 1910, Nishiura Brothers was hired to build Kuwabara Hospital on North Fifth Street, named after Dr. Taisuke Kuwabara. This two-story building was built so that the Issei (first generation) that could not speak English would feel comfortable going to a Japanese-speaking doctor. Dr. Kuwabara did not have a California license, so he had to practice under a Caucasian doctor named Dr. James Beattie. (Courtesy of Japanese American Museum of San Jose.)

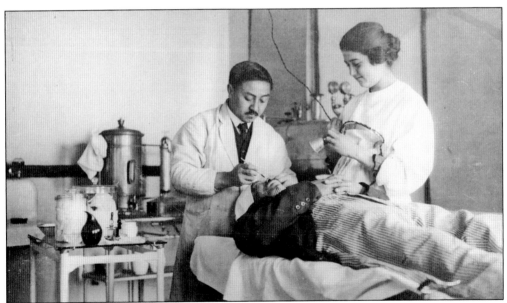

Alice Hori is assisting eye specialist Dr. Ajika Amano, who served at the Kuwabara Hospital from 1924 to 1926. He was the third Japanese doctor to practice there. Amano ended up staying in the Japantown area for a few more years before moving to Los Angeles. (Courtesy of Japanese American Museum of San Jose.)

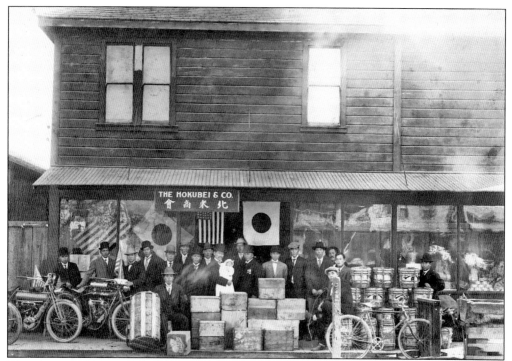

This photograph was taken of the Hokubei and Co. store in 1911. Kumakichi Nakamura (holding the baby near the center) opened the store in 1906. Nakamura was instrumental in helping to start a Buddhist group in Japantown, which eventually lead to the establishment of a church in 1902. The Hokubei and Co. was located at 248 Jackson Street. (Courtesy of Toshio Nakamura.)

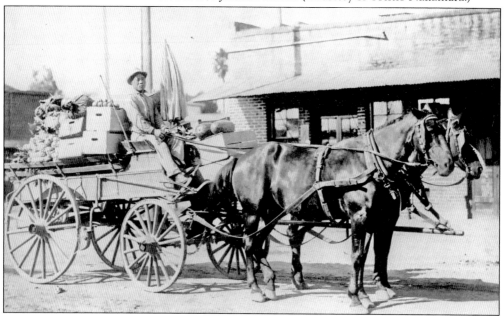

This is a 1910 photograph of R. Nishimura with his horse-drawn cart at the corner of Sixth and Jackson Streets. Currently, the building in the background is part of Kogura Gifts. (Kanemoto Collection, courtesy of R. Nishimura.)

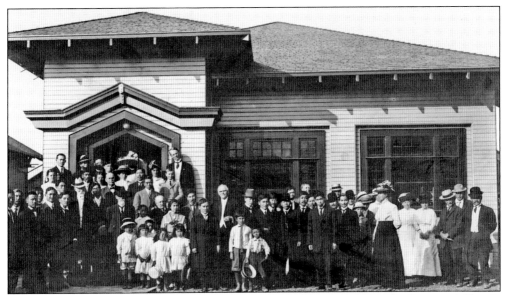

On July 20, 1913, after changing locations several times, the Japanese Methodist Episcopal Church (now Wesley United Methodist Church) was finally able to dedicate a permanent location at 566 North Fifth Street. Pastor Kohichi Matsuoka and Rev. Herbert B. Johnson, superintendent of the Japanese Mission of the Methodist Episcopal Church dedicated the new building. (Courtesy of Wesley United Methodist Church.)

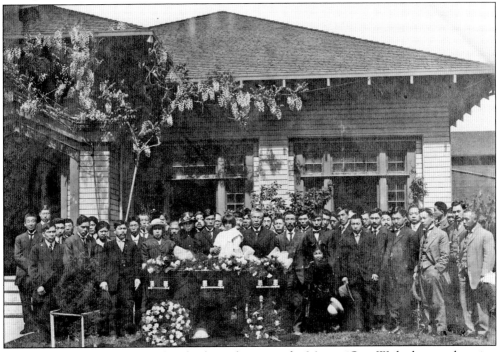

In 1917, family and friends gather for funeral services for Masayo Ota. With the new location of the Japanese Methodist United Episcopal Church (now Wesley United Methodist Church) established, church members were able to gather at one location with classrooms and parsonage under one roof. (Courtesy of Wesley United Methodist Church.)

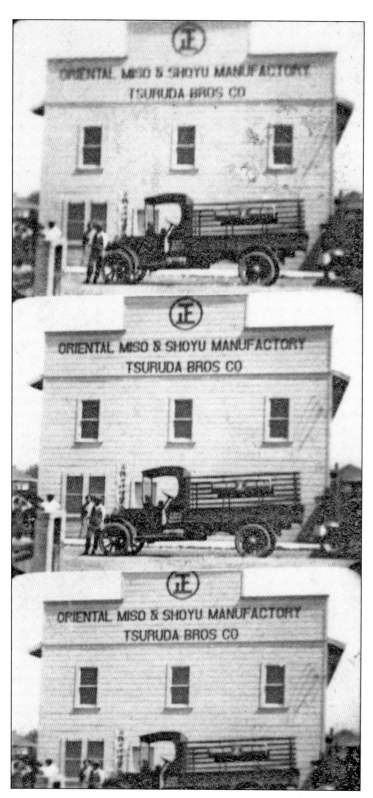

Originally called Tsuruda Miso and Shoyu (soy sauce) Manufacturing Company, Tsuruda Bros. was located at 472 Jackson Street on the property that Grant Elementary School now occupies. Tsuruda Bros. opened in 1922 in Japantown, but by 1927, it had moved to 472 Josefa Street in San Jose. Like many Japanese-owned businesses, they shut down during the war and never resumed operation. (Donated by the Tsuruda family, courtesy of Japanese American Museum of San Jose.)

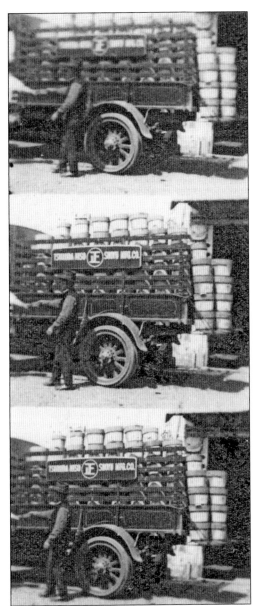

This series of photographs show stacks of shoyu containers being loaded onto a Tsuruda Bros. truck. Interestingly, the first shoyu factory on the continental United States was located in Japantown. Yamamori Jozo-sho (Brewery) started operation in 1897 at 616 North Sixth Street. By 1907, the name was changed to Sa-shi Shoyu Jozo-sho, then in 1908 it was renamed Sanoze (San Jose) Shoyu Jozo-sho. In 1930, the name was Marudai Shoyu Seizo-sho. In 1905, the second shoyu factory on the continental United States, called Sugita Jozo-sho, also opened in San Jose. (Both photographs donated by the Tsuruda family, courtesy of Japanese American Museum of San Jose.)

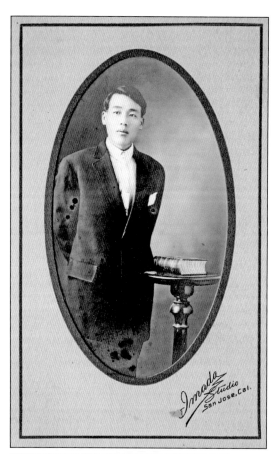

This portrait of Takio Inouye was taken on August 13, 1912, at Imada Studio. There were several photography studios and photographers that worked out of the Japantown area, mainly in the prewar years. Currently, Nagareda Studio, owned by photographer James "Jim" Nagareda, has been in operation for over 25 years at North Fifth and Jackson Streets. (Courtesy of Kamachi family.)

Ishino Photo Studio was located at 221 Jackson Street. This photograph from the 1920s shows, from left to right, Denki, Viola, Sho, and Jie Ishino. This is a rare photograph that shows one of the photograph studios in the area. Ishino Photo Studio would move to 657 North Sixth Street in the mid-1920s. (Donated by the Tsuruda family, courtesy of Japanese American Museum of San Jose.)

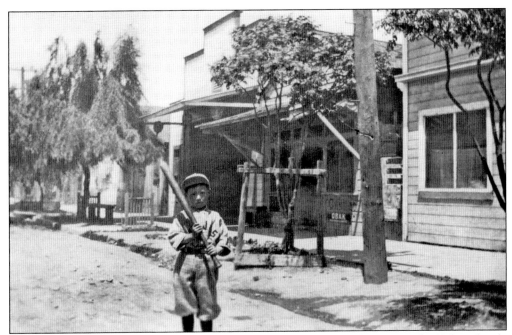

This is a photograph of Masami Kiruna on North Sixth Street in the 1920s. The Kifune family owned a popular boardinghouse at 628 North Sixth Street called the Yamaguchi. In the early 1900s, much of the activity was on Sixth Street because of its proximity to Heinlenville. (Courtesy of Japanese American Museum of San Jose.)

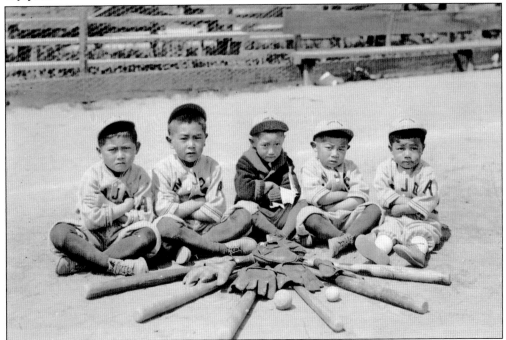

Future baseball stars pose at the Asahi field at Jackson and Sixth Street. From left to right are Haruo Taketa, Wright Kawakami, Hiroshi Itow, Mitsuo "Moffet" Ishikawa, and Nobu Tanabe. Besides baseball, sumo tournaments also took place at Asahi field. (Courtesy of Haruo Taketa.)

From left to right are James Shunji (Toshiko Shigemoto) Kogura, Kohei Kogura, Akiko (Ed Yoshioka) Kogura, Kazuko (Mits Kumamoto) Kogura, Hatsuyo Yamatoda Kogura, baby Chiyeko (Herb Takeda) Kogura, and Tadao (Grace Okida) Kogura. (Courtesy of Richard Kogura.)

Seen here are the charter members of the Nitto Club in an image dated August 18, 1927. From left to right are (first row) Toshi Taketa, Chiri Yamada, Tokio Ishikawa, and Tom Sakamoto; (second row) Ed Higashi, Nic Yamada, Jim Uyemura, Chick Hinaga, and unidentified; (third row) ? Honda, Toshio Santo, Kay Miura, and George Ikeda. Missing from the photograph are Cal Hashimoto, Jim Nishida, and Jim Yamamoto. (Courtesy of Japanese American Museum of San Jose.)

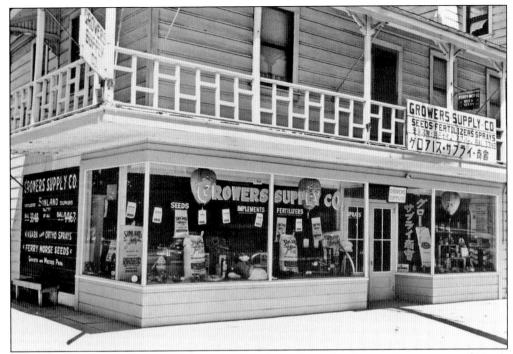

The Okida Bros. General Store occupied 201 Jackson Street (at the northeast corner of North Fifth Street and Jackson Street) from 1911 until the early years of the Great Depression. In 1931, the Growers Supply Company took over the space and catered to the growing number of Japanese involved in the agricultural industry. (Courtesy of Japanese American Museum of San Jose.)

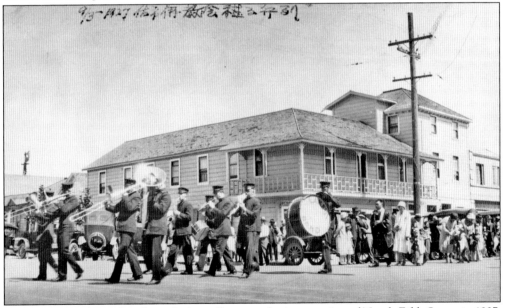

The Lake's Band marches down Jackson Street at the intersection of North Fifth Street in 1927. Here they are leading the Chigo Parade for the 25th anniversary of the San Jose Buddhist Church. In the background is 201 Jackson Street, which is currently owned by the Nagareda family. (Kanemoto Collection, courtesy of Japanese American Museum of San Jose.)

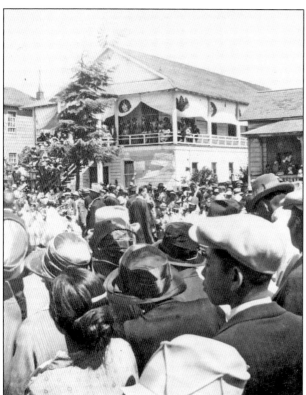

This is a spectator's view of the preparations for the official 1927 Chigo Parade photograph. It shows several people on the stairs and second floor of the San Jose Buddhist Church, along with people on the porch of the house to the right. (Donated by the Tsuruda family, courtesy of Japanese American Museum of San Jose.)

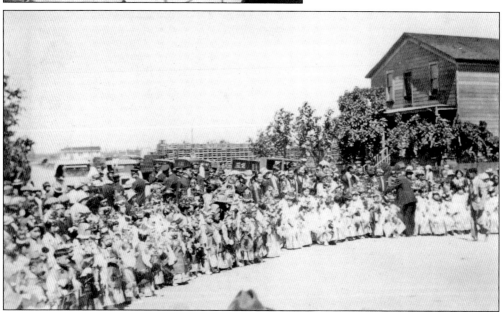

This view of the 1927 Chigo Parade participants looks north on North Fifth Street. In the front, there are rows of children dressed in their traditional Chigo kimono for girls and *hakama* for boys. The Lake's Band members are visible in the dark uniforms and hats on the left side of the photograph. There are several ministers in the middle of the photograph. (Donated by the Tsuruda family, courtesy of Japanese American Museum of San Jose.)

Rev. Gyoen Tsuchihara poses with a Chigo Parade participant in 1927. Tsuchihara was the reverend at the San Jose Buddhist Church from 1925 to 1929. There was a fire at the temple in 1925. When the church rebuilt the damaged areas, they removed the bell tower and moved the staircase to go straight into the temple. (Donated by the Tsuruda family, courtesy of Japanese American Museum of San Jose.)

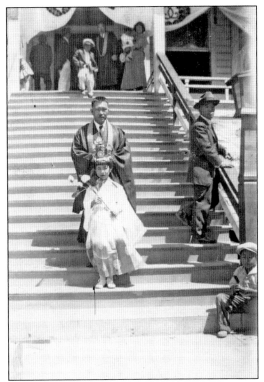

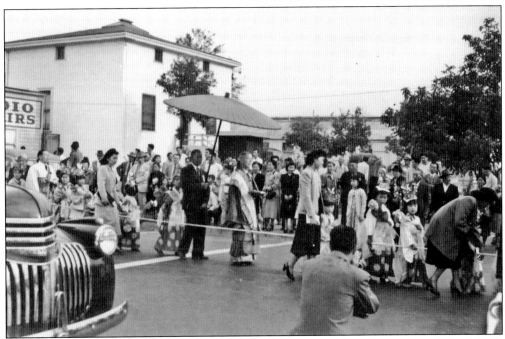

Here is a view of the 1940s Chigo Parade looking west toward the intersection of North Fifth and Jackson Streets. This parade and special service are only held during very special occasions. In this case, San Jose Buddhist Church is celebrating its 25th anniversary. (Donated by George Sato, courtesy of Japanese American Museum of San Jose.)

23

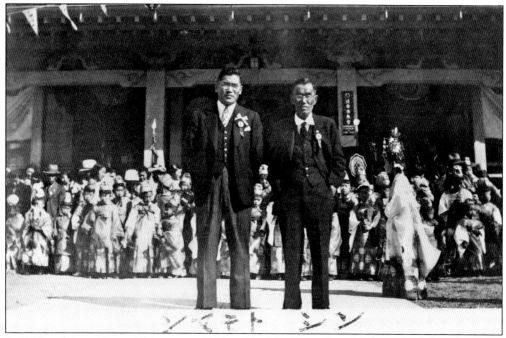

In 1937, architect George Shimamoto (left) and builder Shinzaburo Nishiura (right) pose in front of the newly completed Hondo for the San Jose Buddhist Church. Shinzaburo and his brother Gentaro were also responsible for other landmark Japantown buildings, including the Issei Memorial Building and Okida Hall. (Courtesy of San Jose Buddhist Church Betsuin.)

Since the 1930s, Wayne Basket was located near the edge of Japantown on Horning Street. Owned by the Shimizu family, they specialized in strawberry baskets made from natural materials like spruce or pine. A one-of-a-kind automatic glue berry basket machine was used. The machine could handle a log, called a bolt, that was about five feet long and from 40 to 52 inches in diameter. (Courtesy of Japanese American Museum of San Jose.)

Two

DEVELOPMENT

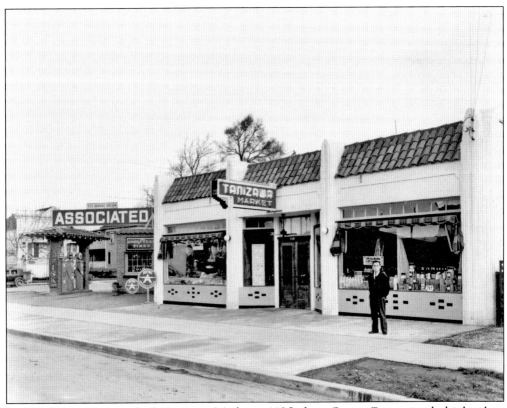

In 1935, Takeo Tanizawa built Tanizawa Market at 140 Jackson Street. Conveniently, his brother-in-law Ed Morihiro owned Ed's Service Station next door, so they were able to help each other construct their buildings. In 1948, Dave Tatsuno opened the San Jose branch of Nichi Bei Bussan, where Tanizawa Market was once located. (Courtesy of Japanese American Museum of San Jose.)

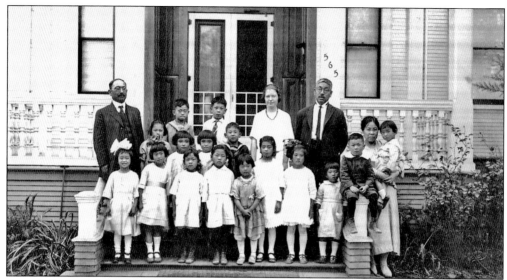

An early Japanese Methodist Episcopal Church (now Wesley United Methodist Church) class stands in front of the Kuwabara Hospital (now Issei Memorial Building), at 566 North Fifth Street, around 1922. The building was the Kuwabara Hospital until the early 1930s, when the Japanese Association purchased it. From left to right are (first row) Grace Okagaki, Tsuguyo Okagaki, Clara Kawakami, Bertha Kawakami, unidentified, Ayako Mineta, Etsu Mineta, Helen Mineta, Sam Takaichi, Mrs. Fuji, and Ellen Okagaki; (second row) Lena Takaichi, Miyo Tokunaga, Kimi Tokunaga, and Chester Ogi; (third row) Pastor Shigeo Fujii, Henry Okagaki, Leroy Takaichi, Madeline Tillman Shore, and Kamekichi Tokunaga. (Courtesy of Wesley United Methodist Church.)

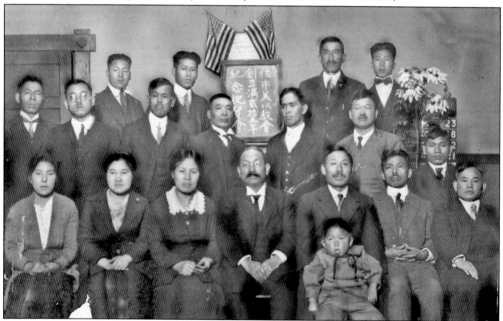

This image was captured during the 25th anniversary celebration of the Japanese Episcopal Methodist Church (now Wesley United Methodist Church) in 1920. During that year, the church established a church school and Bible study class and formed the Fujinkai (Women's Association). (Courtesy of Wesley United Methodist Church.)

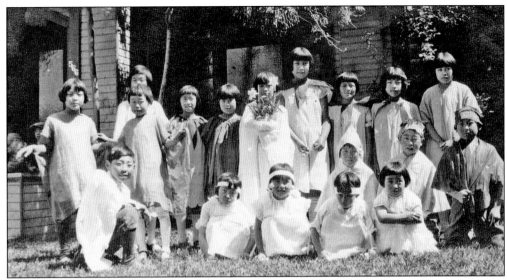

Children are dressed up for an Easter parade in about 1925. From left to right are (first row) Easu Shimizu, Doris Nakahara, Michiko Yamada, Emi Kimura, and Ellen Okagaki; (second row) Sam Takaichi, Dan Ono, and Carl Shimizu; (third row) Bertha Kawakami, Yaeko Ono, Aya Mineta (behind), Grace Okagaki, Martha Takaichi, Tsuguyo Okagaki, two unidentified, Clara Kawakami, and Lena Takaichi. (Courtesy of Wesley United Methodist Church.)

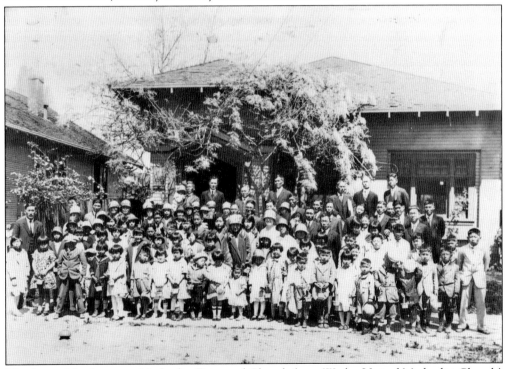

Members of the Japanese Methodist Episcopal Church (now Wesley United Methodist Church) dressed up for Easter Sunday in 1927. In front of the church, there is a wisteria tree. The passing of time can be roughly gauged by the growth of this tree. (Courtesy of Wesley United Methodist Church.)

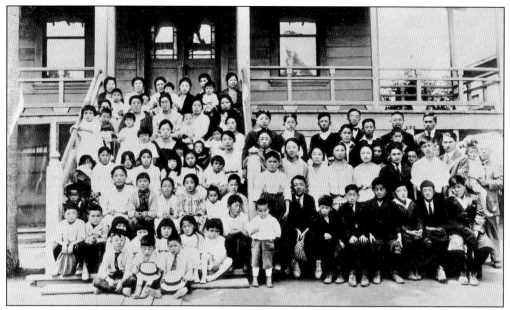

Japanese Language School students are pictured at 523 North Sixth Street in 1923. Rev. Gyoow Sasaki purchased the property on August 20, 1911, to serve as the new temple for the San Jose Hongwanji. Three years earlier, disagreements between Reverend Sasaki and Rev. Honen Takahashi led to a rift in the Buddhist Church congregation. Reverend Takahashi formed the Independent Buddhist Mission, which remained at 640 North Fifth Street. By 1917, the Buddhist Church was reunited with the Fifth Street location used as the main temple, and the Sixth Street location became the church's Japanese Language School. (Courtesy of Japanese American Museum of San Jose.)

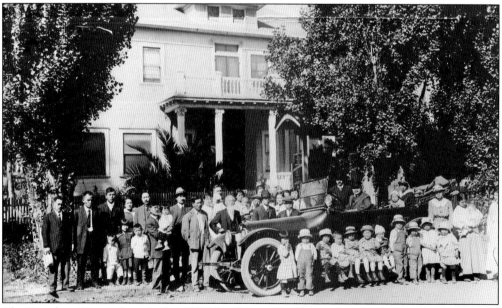

The Kuwabara Hospital was built in 1910 by Gentaro and Shinzaburo Nishiura. The Kumamoto Kenjinkai (group of people from the same region in Japan) were instrumental in leading this project. This building is now known as the Issei Memorial Building and is still actively used by the community to this day. (Courtesy of San Jose–Japanese American Citizens League.)

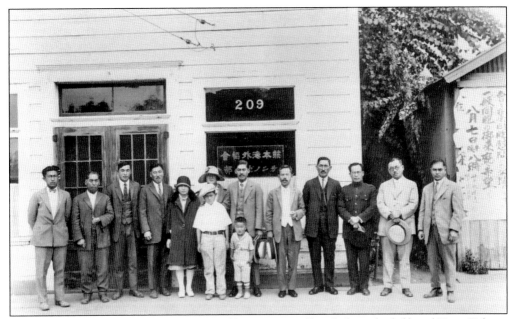

The Taihei Hotel was built in 1913. Owned by Kumataro (fourth from the left) and Tsuru Taketa, the three-story hotel was the tallest building on Jackson Street. In the old days, traveling to San Jose took all day. Visitors could shop, socialize, and then spend a night and take a bath in the hotel before returning home the next day. (Donated by the Tsuruda family, courtesy of Japanese American Museum of San Jose.)

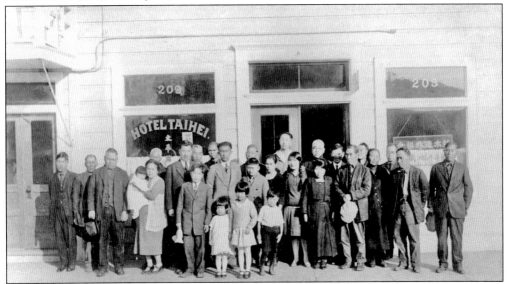

Japantown locals stand in front of the Taihei Hotel in 1927. Located at 209 Jackson Street, the building is currently the home of Headliners, a hat store, and Petite Galleria, an art boutique, on the ground floor with living quarters above and behind. Among the people in the photograph are Kumataro Taketa, the owner of the hotel (sixth from the left, standing below the first "I" in Taihei) and Lincoln Tokunaga (the tallest person standing in the doorway), who would open Jackson Drugs on the southwest corner of Fifth and Jackson Streets. (Courtesy of Japanese American Museum of San Jose.)

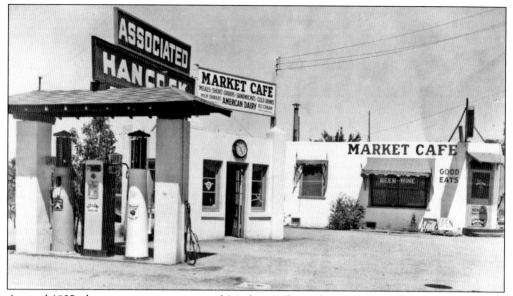

Around 1935, there was a gas station and Market Café on the outskirts of Japantown. Located at the corner of Seventh and Taylor Streets, the Market Café probably catered to the workers at the Grower's Market next door. On the other corner of this property, another restaurant would open and eventually become Bini's Bar and Grill. Currently, Pavona Apartments are located on this property. (Courtesy of Dale Yoshihara.)

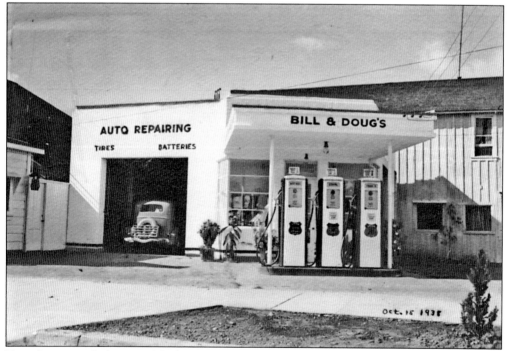

For a short period of time, 197 Jackson Street (the northwest corner of Fifth and Jackson Streets) was occupied by the Kitazawa Seed Company. In 1938, Bill Yasukawa and Doug Omori opened a service station. After the war, the Murotsune family bought the property and changed the name to Mike and Roy's Service Station. (Courtesy of Murotsune family.)

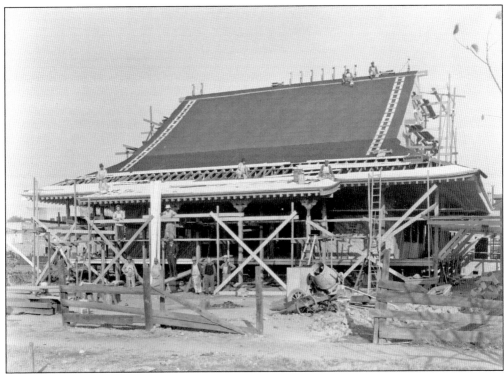

The San Jose Buddhist Church, located at 640 North Fifth Street, was built in 1937 by the Nishiura Brothers Construction Company for approximately $33,000. The construction company donated much of their labor costs. The architect, George Shimamoto, based the design on a smaller version of the Byodo-in temple in Kyoto. The parsonage for the head minister was built north of the temple. (Both photographs courtesy of San Jose Buddhist Church Betsuin.)

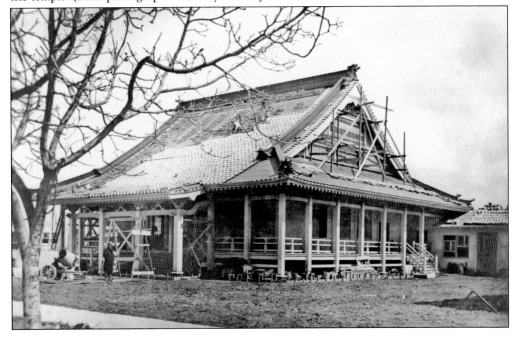

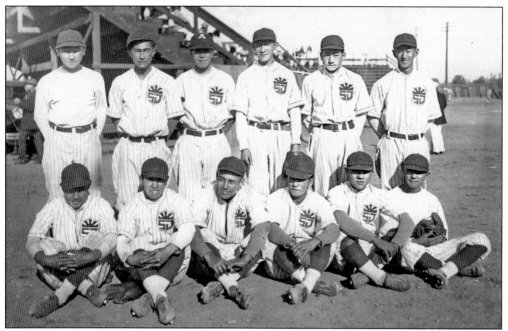

The Asahi baseball B-team is pictured here in 1929. From left to right are (first row) "Nurmi" Honda, George Ikeda, Tosh Santo, Henry Tsuruda (manager), Tosh Takeda, and Kay Miura; (second row) Linc Tokunaga, Mike Yamada, Jim Uyejo, Jim Uyemura (captain/coach), Chick Hinaga, and ? Handa. (Donated by the Tsuruda family, courtesy of Japanese American Museum of San Jose.)

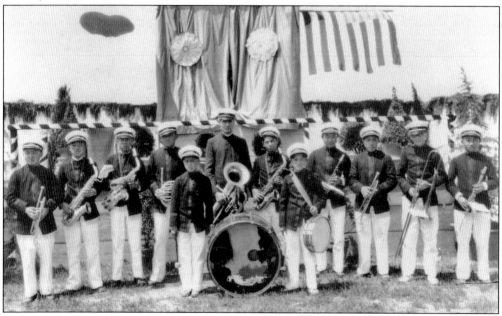

The Young Men's Buddhist Association (YMBA) was started by Rev. Ganyu Watanabe and Yaichi Yamakawa on April 18, 1925. Watanabe was the head minister from 1924 to 1925. The YMBA marching band was organized in 1930 with the help of Francis Higuchi. (Donated by the Tsuruda family, courtesy of Japanese American Museum of San Jose.)

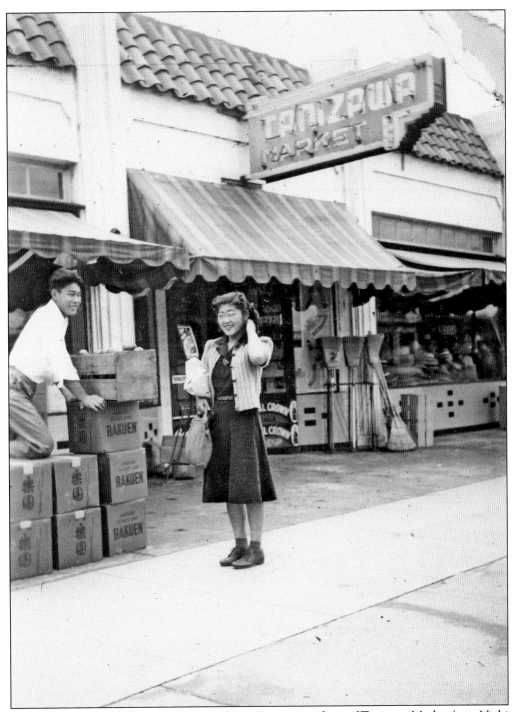

May (Shimoguchi) Ishikawa is talking with Jun Tanizawa in front of Tanizawa Market (now Nichi Bei Bussan) on Easter Sunday 1941. Several of the local businesses had elevators in the sidewalk where they could bring inventory downstairs for storage. Unfortunately, water would get inside the basements when it rained. Although the elevators are no longer being used due to safety reasons, the elevator doors are still visible. (Courtesy of Jean Shimoguchi.)

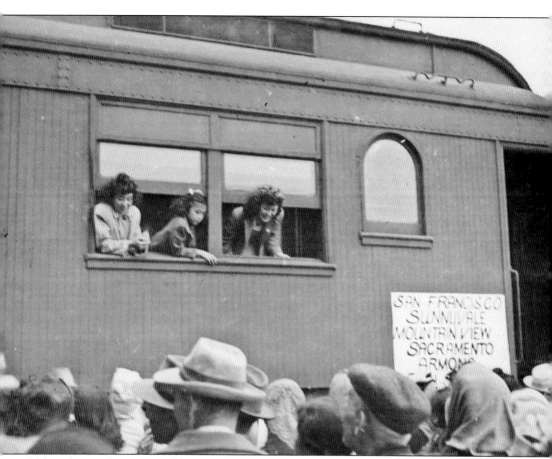

Although most Japanese and Japanese Americans in Japantown were loyal citizens, the events on December 7, 1941, would change their lives dramatically. After the bombing of Pearl Harbor, they prepared for the worst. Some people moved inland and others moved to other states that were considered "Japanese friendly." Because of the fear of being rounded up by the authorities, many people destroyed or burned anything that might connect them to Japan. Precious family photographs, letters, and artifacts were all destroyed. On May 24 and 25, 1942, anyone of Japanese ancestry was ordered to meet at the men's gymnasium at San Jose State College to register to be evacuated to remote internment camps. (Courtesy of Lee Uyeda.)

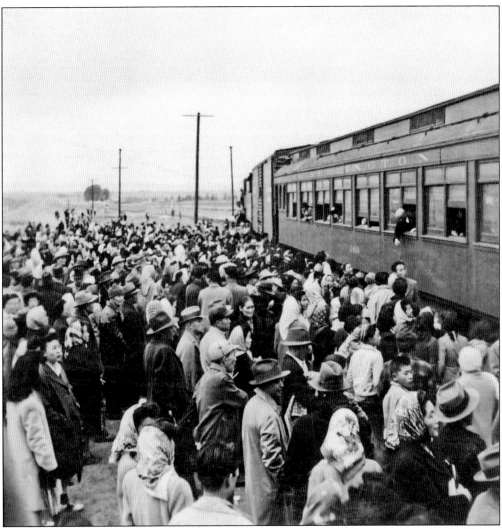

Due to the evacuation, the businesses in Japantown had to close their stores and sell off their inventory for pennies on the dollar. If they were lucky, some families were able to entrust their possessions to their friends. In these photographs, people are preparing to board the trains that will take them to the Santa Anita Race Track before being sent to Heart Mountain, Wyoming. People were only allowed to bring what they could carry, while not knowing where or for how long they would be gone. Little did they know that they were being sent to remote internment camps with harsh weather conditions. (Courtesy of Lee Uyeda.)

Tom and Mary's

SNACK SHOP

▼

FOUNTAIN & DINNER SERVICE

CIGARETTES — CANDIES

193 E. Jackson St.　　　　　　　　　San Jose

You are always welcome at . .

JACKSON DRUGS

Complete
Prescription Service

LINCOLN TOKUNAGA, Prop.

☆

Photo Finishing　　Greeting Cards
Magazines　　　　Sick Room Needs
Toiletries　　　　Candies
Stationery　　　　Ice Cream

☆

198 Jackson St. Cor. 5th　　San Jose
Phone Ballard 1465-W

Bill W. Furukawa

Watch and Jewelry Repairing

Columbia 10140-W

599 N. Fifth St.　　San Jose

Roy's Grocery
and
Fish Market
(Fukumura Co.)

PHONE BALLARD 2028-W

169 JACKSON STREET
SAN JOSE

E. Fukuda　　　T. Fukuda

Jackson Barber Shop

194 East Jackson St.

San Jose

These 1949 advertisements are from the 50th anniversary yearbook for the San Jose Buddhist Church. They give a fun view of how things used to be. It is interesting that all of these businesses are named after the owner(s) or include the street name. Other business names include Santo Market, Dobashi Market, Kay's Shiseido, Hashimoto Drug Store, Sakamoto Barber, Fourth Street Pharmacy, Tanizawa Market, Jackson Jewelry, Kogura Gifts, Amy's Beauty Salon, etc. Other businesses chose to show their connection to Japan. Some business names include Okayama Restaurant, Minato Restaurant, Shu-ei do, Nikaku, Koto Restaurant, Nagasaki Restaurant, and Ginza Restaurant. (Both photographs courtesy of San Jose Buddhist Church Betsuin.)

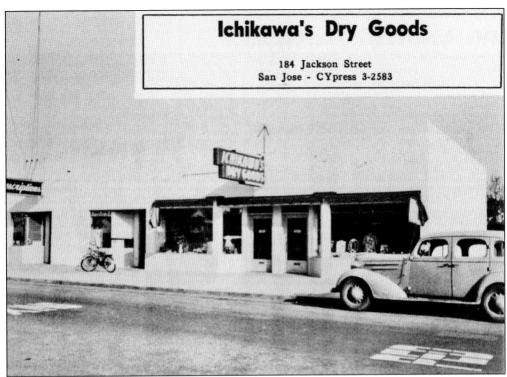

Ichikawa's Dry Goods

184 Jackson Street
San Jose - CYpress 3-2583

Ichikawa's Dry Goods and Nishioka Bros. Fish Market are also good examples of businesses using their surname as their business name. Early businesses were often named after the owners or after the name of the place they were from in Japan. Some customers would frequent a business like Okayama Restaurant, for instance, because they were also from Okayama in Japan or because they had a connection to the namesake. These days, the businesses in Japantown have names like Headliners, Zonkey, Cukui, Sole On Ice, and State of Grace, to name a few. (Both photographs courtesy of San Jose Buddhist Church Betsuin.)

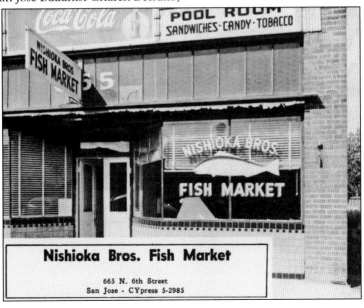

Nishioka Bros. Fish Market

665 N. 6th Street
San Jose - CYpress 5-2985

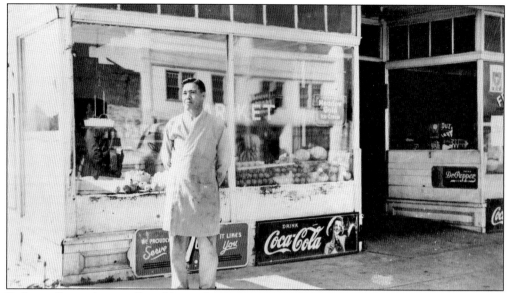

Yoshijiro Santo (pictured) and his wife, Misaye, opened Santo Grocery at 248 Jackson Street instead of returning to farming after the war. Currently, the store is called Santo Market and is located at 245 East Taylor Street. It is being operated by the third generation of the Santo family. On occasion, one may even spot some of the fourth-generation family members helping out. (Courtesy of Japanese American Museum of San Jose.)

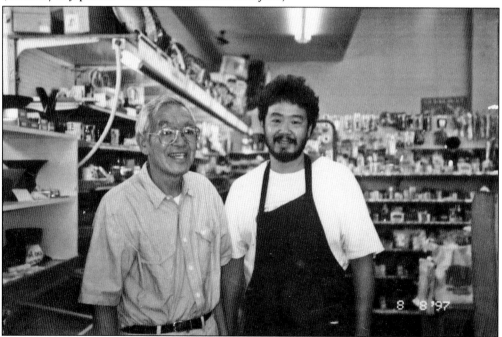

Earl Santo, who is the second-generation owner of Santo Market, is pictured with his Sansei (third generation) son Mark. Over the years, Santo Market has evolved with the times. They have added coffee, shave ice, barbequed foods, and a deli. Santo Market, on the corner of Taylor and Sixth Streets, is one of the few Japantown businesses that has its own parking lot. (Courtesy of Santo family.)

Jio Nusery was established in 1910 about a mile from Japantown at Nineteenth and Julian Streets. Joanne (Jio) Makishima recounts, "During the war, someone agreed to look after the land; and so although it was overgrown with weeds, my dad and uncle were lucky enough to reestablish the business when they returned from camp." A wisteria tree that was planted when they opened continued to grow and provide shade and enjoyment to their friends and customers for many years. Joe and Mary Jio stand under the tree in the above photograph. When the nursery closed in the early 1990s, a customer purchased and dug up the tree. Although part of the lot is still vacant and the original tree is no longer there, a new tree has sprouted from the original roots. In the photograph below, Sal (left) and Joe Jio are standing in front of the nursery. (Both photographs courtesy of Joanne [Jio] Makishima.)

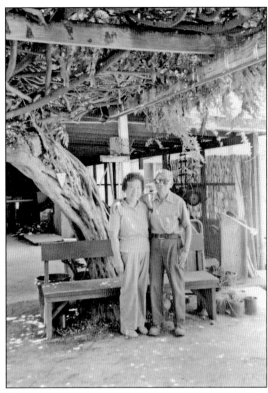

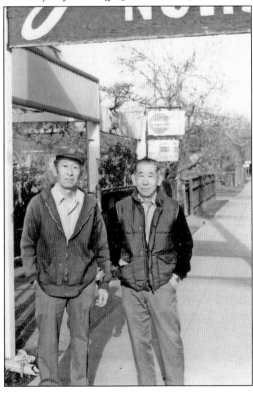

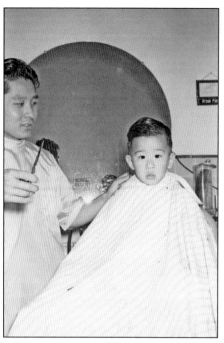

In 1954, Atsuo Fukuda was released from the Army and resumed his career as a barber with his brother John. Here, he is cutting his nephew Curt Fukuda's hair at Jackson Barber Shop at 194 Jackson Street, currently occupied by Orange Crush Studios. There was such a demand for services like barber shops in Japantown, there were five in operation during that time. (Courtesy of Curt Fukuda.)

Mich Shiomoto is standing in front of Mike & Roy's Service Station at the corner of North Fifth and Jackson Streets. Besides coffee shops, the service stations were also places where people would hang out and talk about "the good old days." A large section of Japantown is visible from this corner, considered the hub of the area. (Courtesy of Lillie Morita.)

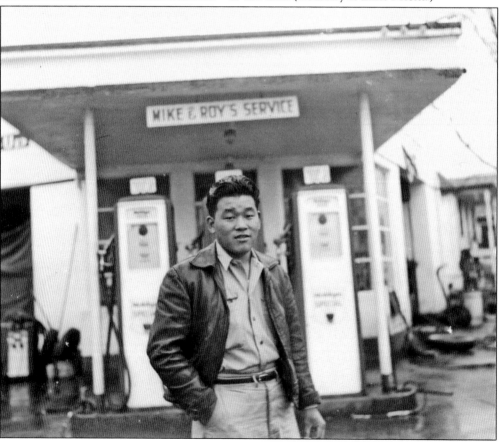

Eiko (Hirano) Oka worked at Taketa's coffee shop around 1958. Located at 211 Jackson Street, this lunch counter was popular with locals and the nearby cannery workers. In 1965, Hank Nishijima opened Hank's Coffee. (Courtesy of Eiko Oka.)

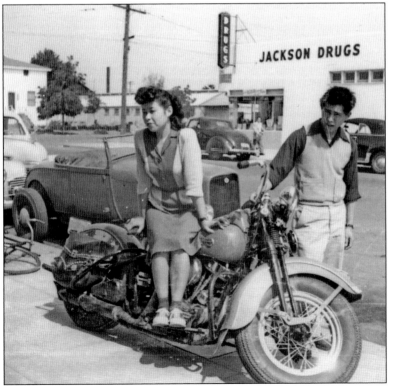

Kay Funatsu and Don Hama hang out in front of Tom & Mary's coffee shop. Behind them is Jackson Drugs store, owned by Linc Tokunaga, who built the store after the war. (Courtesy of Lillie Morita.)

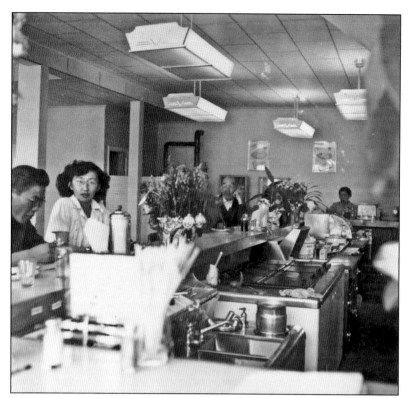

Lunch counters like this one inside of Tom & Mary's were popular after the war. The Fourth Street Pharmacy and Taketa's coffee shop also had counters where the "locals" would hang out. (Courtesy of Lillie Morita.)

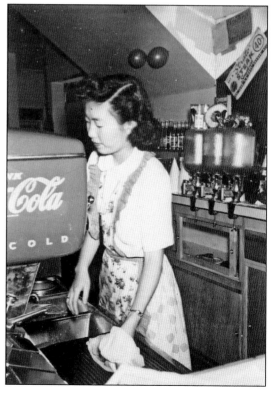

Lillie Morita worked at Tom & Mary's, her brother and sister's restaurant, in 1953. Most of the lunch counters in Japantown would serve standard American lunches like sandwiches and burgers. Often, one could also get some rice and pickled vegetables. (Courtesy of Lillie Morita.)

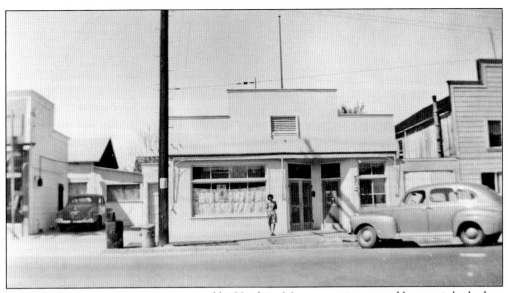

The tofu shop on Jackson Street, started by Heishiro Marumoto, is pictured here as it looked on March 25, 1946. In two years, the shop would become San Jose Tofu, operated by the Nozaki family. Several of the businesses had living quarters behind their shop where the owners would stay. In this photograph, a driveway that leads to a house behind the business next door can be seen. (Courtesy of Lillie Morita.)

Tom & Mary's was a popular place to grab something quick to eat and to see old friends. In this photograph, Tom Murotsune (left) and Momoru Yamaichi (right) are standing outside. Currently, Gombei Restaurant is operating at this location. The Murotsune family also owned the gas station in the background. (Courtesy of Lillie Morita.)

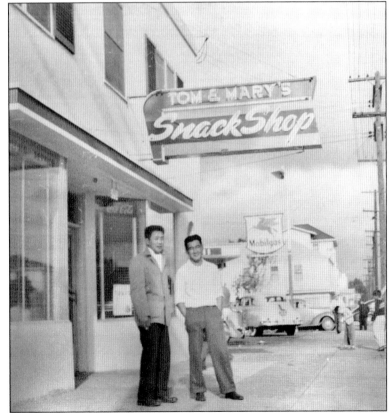

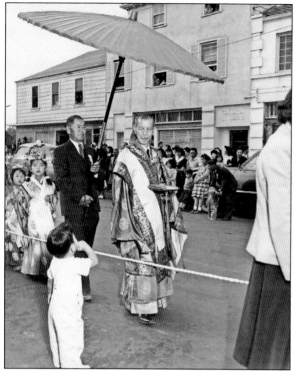

The San Jose Buddhist Church celebrated its golden anniversary in 1949. As part of the celebration, a parade is held where the children dress up in ornate clothing that is only worn for such an auspicious occasion. In the above photograph, the parade passes by the Taketa Building (originally the Taihei Hotel, owned by the Taketa family). On the bottom floor, there's a beauty shop. On the second floor, there is a dentist office where Dr. G.I. Kawamura practiced. Some people can be seen looking through a couple of the windows. In the photograph below, several spectators are standing in the center of the intersection of North Fifth and Jackson Streets. (Both photographs by Bob Laing, courtesy of San Jose Buddhist Church Betsuin.)

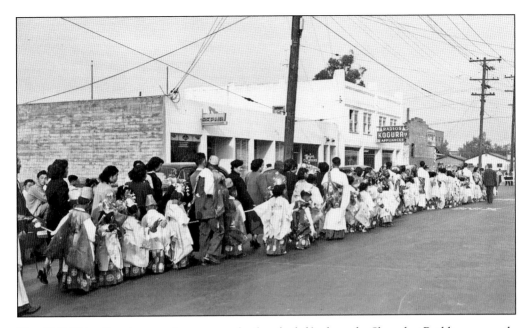

The 1949 Chigo Parade passes by an empty lot (on the left) where the Shanghai Building currently stands. The next building to the right was owned by the Kawakami family. There is a shoe repair shop, Dr. Kawakami's office, Camille Beauty shop, and Major Cleaners, operated by Meiji Kawakami. When Meiji Kawakami left, James Suyeishi took over the cleaners and changed the name to Crown Cleaners. The next building is Kogura Co., then a brick building that Kogura currently owns. Stucco was applied to cover the bricks to give it a consistent look with the building next door. In the image below, the Buddhist Church 50th Anniversary Banquet takes place in the old gym building. (Both photographs by Bob Laing, courtesy of San Jose Buddhist Church Betsuin.)

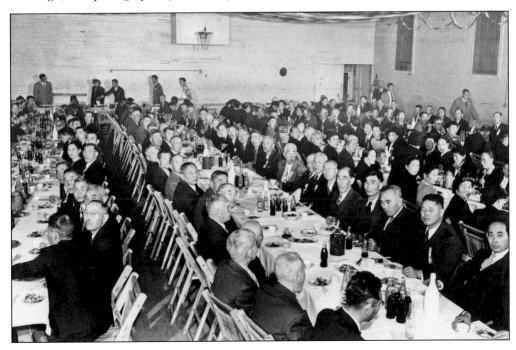

The Nichi Bei Bussan store is pictured here one week prior to its official grand opening on July 11, 1948. Before the war, the building was the Tanizawa Grocery Store. (Photograph by Dave Tatsuno, courtesy of Japanese American Museum of San Jose.)

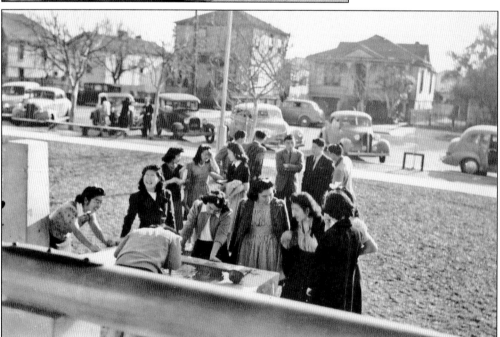

Conference attendees are seen in front of the San Jose Buddhist Church (now San Jose Buddhist Church Betsuin). They are purifying themselves by drinking from the "Mitarai," which was donated by the Mitarai family on November 2, 1940. This photograph from the porch provides an excellent view of the opposite side of North Fifth Street before the buildings were torn down and the Buddhist Church Education Building and Murotsune Apartments were constructed. (Courtesy of Grace Okida Kogura.)

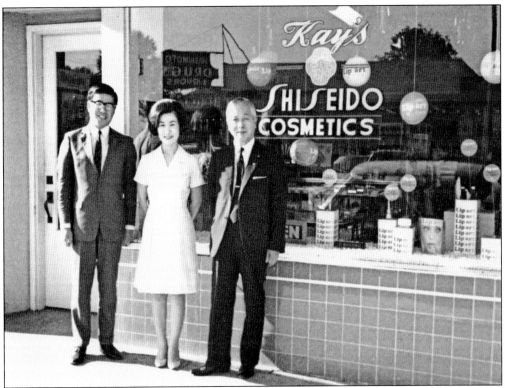

Kay's Shiseido Cosmetics has been in Japantown for over 50 years. It is the first Shiseido Cosmetics store in the continental United States. Initially the store was located at 205 Jackson Street. Pictured above is Kay with representatives from Shiseido. When the Taketa family decided to sell their building on the corner of North Fifth Street and Jackson Street, the Nagaredas purchased it and built a new structure. At one time, Kay's sold record albums, compact discs, eight-track tapes, and magazines from Japan. One product from Japan that has survived over the years is Hello Kitty. Kay's was the first store in the continental United States to start selling this popular character. Over one year after Kay's starting selling Hello Kitty, Sanrio opened their first corporate store at Eastridge Mall, which is now closed. (Both photographs courtesy of Nagareda family.)

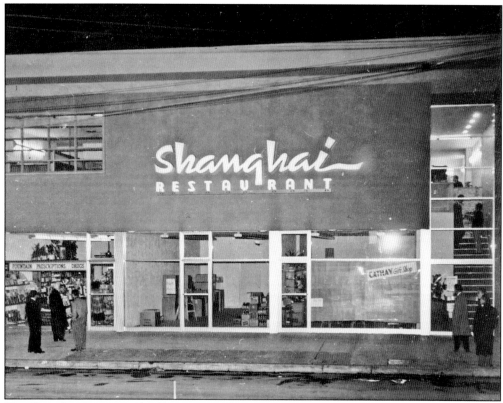

The Shanghai Restaurant building was newly constructed by the Nishiura Bros., who were hired by the Dobashi family. The early tenants in this building were Soko Hardware, Shuei-Do Manju Shop, Cathay Gift Shop, and Shanghai Restaurant upstairs. Today, Shuei-Do Manju Shop is still in its original location. (Courtesy of Reiko Iwanaga.)

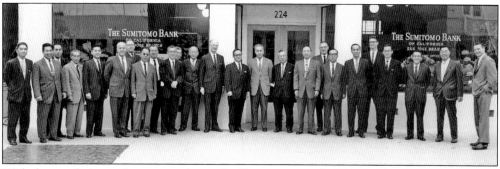

With the population and commercial growth of Japantown in the 1950s and 1960s, it was a matter of time before the Japanese banks would take notice. Sumitomo Bank was one of the first to move into the area. The bank was located in a Dobashi building, which was directly across the street from the Shanghai Restaurant. Sumitomo Bank eventually bought property and moved into a building on First Street. (Photograph by Pat Itatani, courtesy of Japanese American Museum of San Jose.)

The Mariani Dry Fruit Company built these barrack-like buildings for the Japanese that worked for them after returning from the internment camps. Mum Arii stands in front of the barracks in 1983, just before they were demolished. (Photograph donated by Mum Arii, courtesy of Japanese American Museum of San Jose.)

Wesley United Methodist Church was growing. In 1989–1990, the church building was remodeled, and a chapel building was constructed. With an increasing church school enrollment, parcels adjacent to the church were purchased. The Education Building was built in 1959, and a second floor was added in 1964. (Courtesy of Japantown Business Association.)

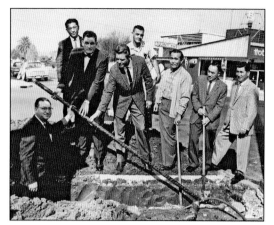

The City of San Jose has been working together with the Japantown merchants for many years. Dated December 1962, local Japantown leaders from the Jackson-Taylor Business and Professional Association, along with city representatives, are pictured during a ground-breaking ceremony to install traffic signals at Fourth and Jackson Streets. From left to right are city engineer Paul Meier, Dr. Robert Okamoto, Mayor Robert Welch, city inspector Warren Wagner, contractor Smith Howard, Mitz Kumamoto, Dave Tasuno, and Jim Sakamoto. (Courtesy of Dr. Robert Okamoto.)

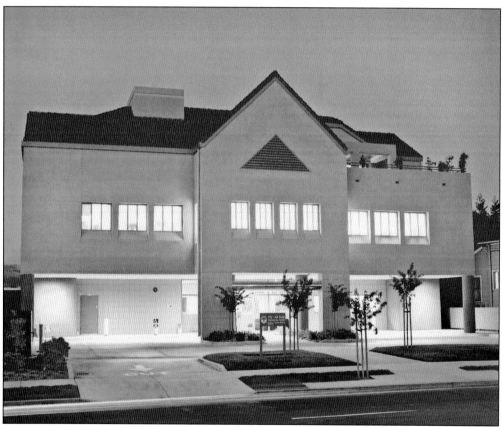

Yu-Ai Kai's mission statement is the following: "To promote healthy aging, successful independent living and advocate for all seniors, while embracing Japanese American tradition." Akira Kamiya writes, "The origins of Yu-Ai Kai can be traced to the early 1970's when a group of San Jose students calling themselves Asians for Community Action (ACA) brought their multi-discipline expertise and political activism into the Japantown community." After using temporary facilities at Wesley United Methodist Church and the Issei Memorial Building to run its growing number of programs, in March 1993, a new facility was built. (Photograph by James Nagareda.)

Formally the Kuwabara Hospital, the Issei Memorial Building (IMB) is in the care of the San Jose–Japanese American Citizens League (SJ JACL). In 1981, the league started a fund drive to raise $300,000 to restore the building. (Photograph by James Nagareda.)

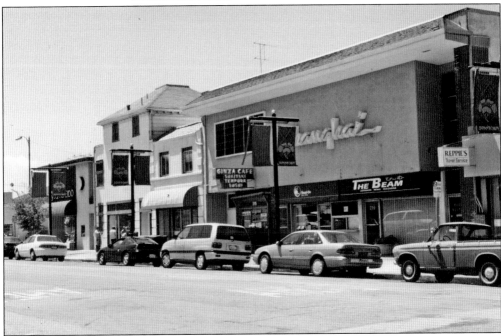

The north side of Jackson Street (between North Fifth and Sixth Streets) is pictured in 1988. From the left is Kay's Shiseido, Nagareda Studio, Hank's Rod and Reel, Bento Xpress, Ginza Café, Shuei-do Manju Shop, the *Beam* newspaper, and Reppies Travel. (Photograph by James Nagareda.)

In the late 1980s and 1990s, the federal and local government started to invest in qualified communities. Japantown benefited from this by having the building facades updated, banner and light poles installed, utilities undergrounded, along with the addition of historical markers. (Both photographs by James Nagareda.)

Three

ACTIVITIES

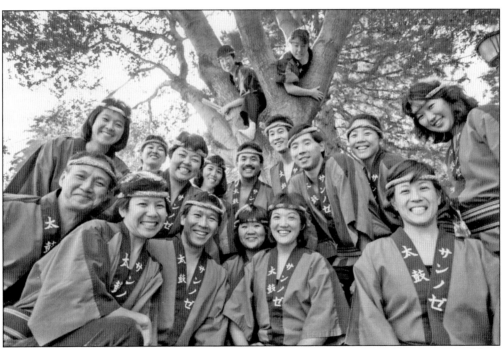

San Jose Taiko (SJT) started as a cultural activity to attract young people at the San Jose Buddhist Church Betsuin. Founded in 1973 by Roy Hirabayshi, Dean Miyakusu, and Rev. Hiroshi Abiko, SJT has become a professional touring company. Taiko existed in ancient Japan over 2000 years ago as a communication tool or as an instrument for religious rituals. Today, SJT has taken the traditional rhythms and added a fresh mix of world rhythms, jazz, and funk to create their unique sound. In addition, members design their costumes, create new compositions, and develop choreography to create world-class productions. (Photograph by Curt Fukuda.)

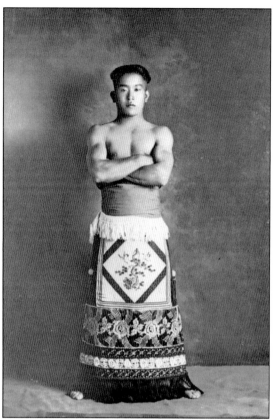

A *mawashi* is a belt or loincloth that the *rikishi* (sumo wrestler) wears during training or competition. Jack Kurasaki is wearing his formal mawashi that is made of silk and is worn during the ring entering ceremony. Only wrestlers in the upper divisions are allowed to wear these *mawashi*, which can weigh 8 to 10 pounds. (Courtesy of Kurasaki family.)

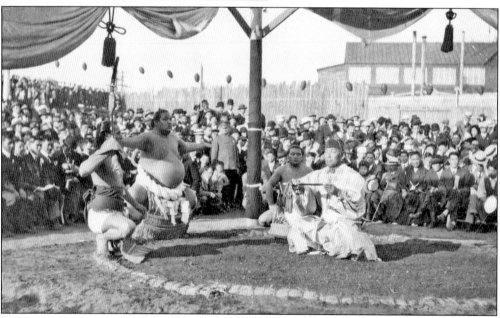

Sumo tournaments were held at the Asahi baseball field at the southeast corner of Sixth and Jackson Streets. When the Asahi baseball team moved to their new field in 1926, a permanent sumo ring was constructed. (Courtesy of Japanese American Museum of San Jose.)

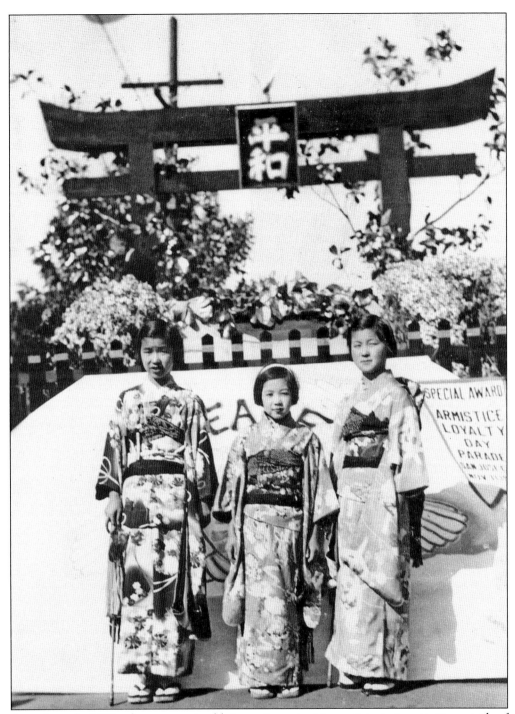

As early as the 1920s, the community felt it was important to participate in activities outside of Japantown. In 1938, these young girls are dressed up in their beautiful kimonos for the Armistice Loyalty Day Parade, where they won a special award for their float. In the photograph are, from left to right, Kazuko Kogura, Masuye Idehara, and Polly Shinagawa. (Courtesy of Japanese American Museum of San Jose.)

The San Jose Young Women's Buddhist Association (YWBA) basketball team, called the Purplettes, are seen here in 1938. From left to right are (first row) Tatsuye Suyeishi, Tsuneko (Sakamoto) Taketa, Alice (Hinaga) Taketa, and Iris (Imada) Kawamoto; (second row) coach Dave Sakamoto, Masako (Kawakami) Taketa, Fumi (Tanabe) Koga, Asaye (Sakamoto) Honda, and Pauline (Yoshida) Tsuruda. (Courtesy of Japanese American Museum of San Jose.)

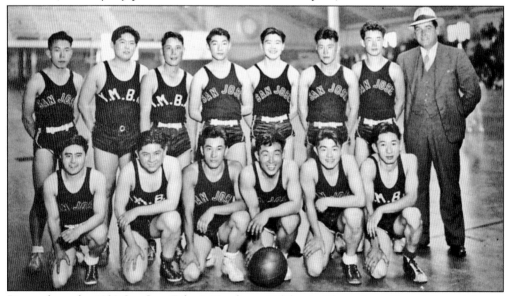

Pictured are the 1938 San Jose Zebra's Northern California Champions. From left to right are (first row) Tets Kifune, Clark Taketa, Harry Sekigahama, George Hinaga, Moffett Ishikawa, and Sal Jio; (second row) Tad Kita, Sako Taketa, Tets Santo, James Okida, Harry Dobashi, Harry Yoshioka, Tom Ichishita, and coach Everett Roseveare. (Courtesy of Japanese American Museum of San Jose.)

There were a lot of parties behind the Kogura building. From left to right are (first row) Yuri Kawakami, Amy (Miyakawa) Akizuki, May (Shimoguchi) Ishikawa, and Kazu (Kumamoto) Kogura; (second row) Marian Funai, Sayo Kurasaki, and Polly Shinagawa; (third row) Tetsuko Okita, Fumi Morita, Aya (Kamachi) Kifune, and Grace (Kogura) Okita. (Courtesy of Jean Shimoguchi.)

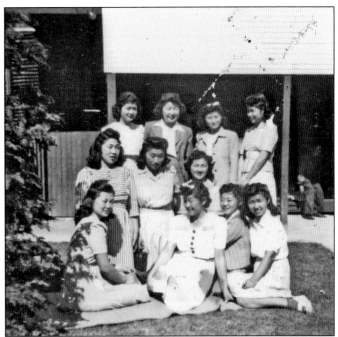

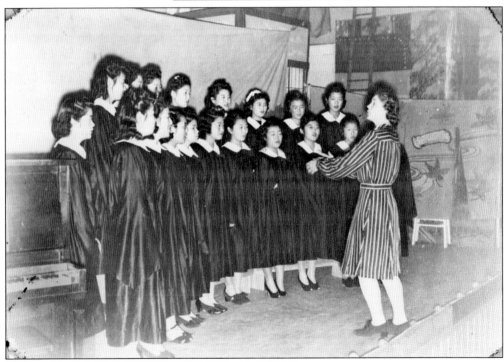

This image was captured during the church dedication at the Japanese Hall on November 3, 1940. From left to right are (first row) Nadine Nakahara, Sayo Kurasaki, Mitsuko ?, Grace Okita, Kay Kani, Yuri Kawakami, Bernie Hinaga, May Ishikawa, Agnes Akizuki, and Amy Akizuki; (second row) Tetsuko Okita, Kazu (Kumamoto) Kogura, Marian Funai, Fumi Morita, Grace ?, Aiko ?, Aya Kamachi, Sumi Kurasaki, and Chizu ?. (Courtesy of Jean Shimoguchi.)

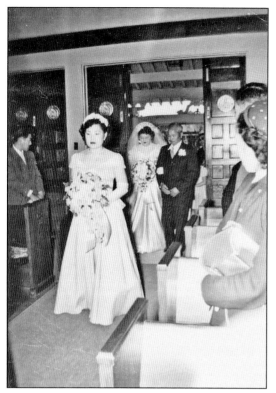

The wedding of John Masashi Shinseiki and Margaret Chiyoko Yuki took place on April 18, 1948, at the San Jose Buddhist Church. After the newly married couple thanked each of their guests for attending, the guests saw the couple off with a shower of rice to bring prosperity, fertility, and good fortune. The reception was at the Mandarin Restaurant, which was one of the locations in Japantown where a large group could have a celebration. If a party was too big, Okida Hall could be rented out, and Mandarin Restaurant would cater the event by bringing the food through the back door. (Both photographs courtesy of Jay Shinseiki.)

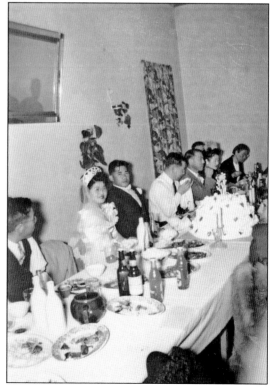

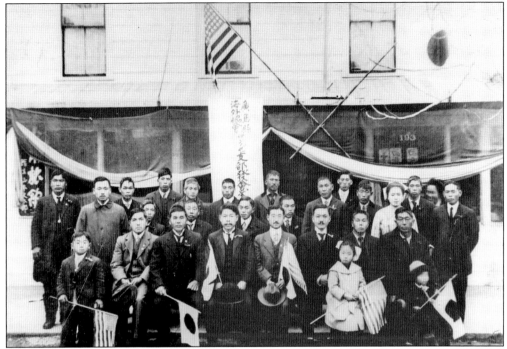

The newly established Hiroshima Kenjinkai (group based on an area in Japan) stands in front of the Yamamoto Ya (currently Gombei Restaurant at 193 Jackson Street). Kenjinkais have gatherings where attendees socialize and form bonds that benefit their businesses and enrich their personal lives. (Courtesy of Japanese American Museum of San Jose.)

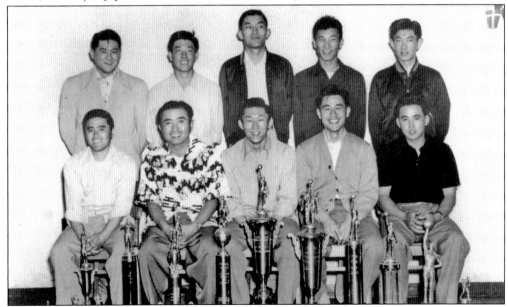

The championship San Jose Zebras basketball team is pictured here around 1950. From left to right are (first row) Ted "Pappy" Kifune, Frank Shimada, Chi Akizuki, Tom Taketa, and Frank Yoshioka; (second row) Masao Taketa, Hide Kashima, George "Toby" Yamamoto, Jiro Nakamura, and Fred Morita. (Courtesy of Chi Akizuki.)

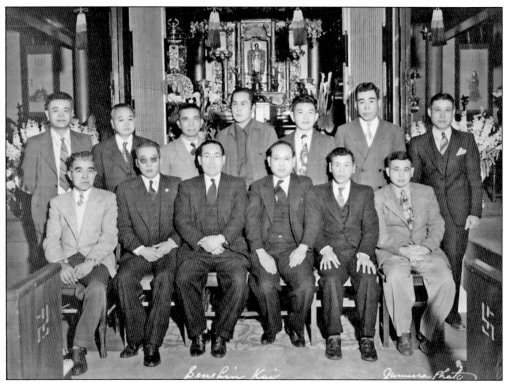

This is the Senshin Kai at the San Jose Buddhist Church (now San Jose Buddhist Church Betsuin). Senshin Kai means "a gathering to cleanse one's mind." Rev. Tokujo Tsumura started the group in 1932 as a way for Japanese-speaking members to have monthly services and socializing. Most of the original members were men from the Young Buddhist Association (YBA). It would be several years before women joined the group. By the late 1950s, the number of men and women was almost equal. Seen above is the 1950 Senshin Kai group; from left to right are (first row) Takeshi Mitsunaga, Tetsudo Uyeda, Rev. Chikara Aso, Rev. Kiyoto Nagatani, Noboru Tomisaka, and Frank Kurotsuchi; (second row) Teruyoshi Nomura, Kazuichi Asanuma, Shigeo Saito, Inazo Noda, Joe Akahoshi, Minoru Higashi, and Waturu Fujii. Below is the 1974 Senshin Kai group. (Above photograph by Fred Jumura; both photographs courtesy of Fumiko Fujii.)

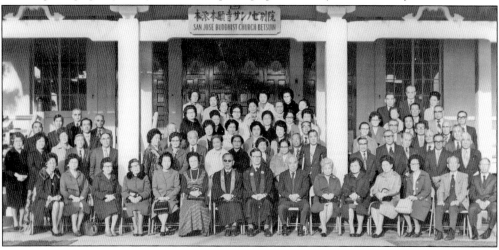

Three friends dance at the Obon Festival in 1951. The early years of the *obon* dance took place on Jackson Street. From left to right are Lorena Fujii, Joyce Fujii, and Kimiko Nakayama. (Courtesy of Fumiko Fujii.)

Girls posing for a photograph after the 1949 Chigo Parade. The parade was held to celebrate the 50th anniversary of the San Jose Buddhist Church. From left to right are (first row) Lois Santo, Betty Jean Higashi, Alene Fukumura, and Sally Sakamoto; (second row) Nora Sato, Grace Hane, Sally Endo, and Kaye Endo. (Photograph by Bob Laing, courtesy of San Jose Buddhist Church Betsuin.)

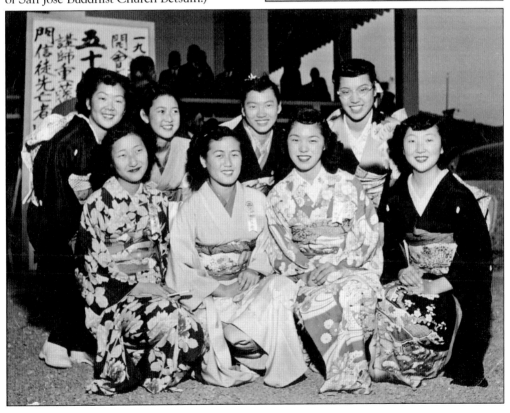

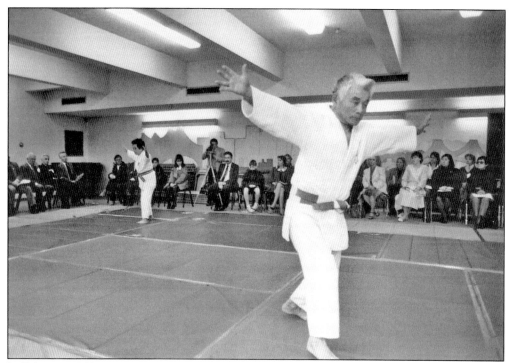

In February 1992, a momentous occasion occurred when Sensei Keiko Fukuda and Sensei Don "Moon" Kikuchi, performed the "forms of five" Kata together for the Kagami Biraki ceremony. This annual New Year celebration features a school (dojo) year of review and rededication of one's self to judo. Prof. Jigoro Kano, the founder of Kodokan Judo, started this traditional ceremony. Keiko Fukuda was the highest-ranked female judoka in the world. She was Professor Kano's last surviving student. (Courtesy of Dan Kikuchi.)

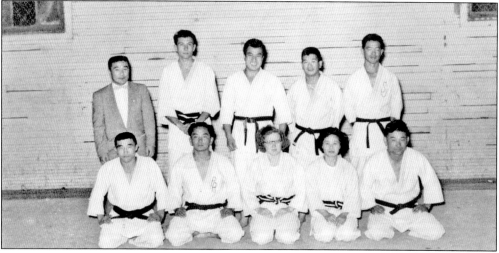

This c. 1951 judo group photograph documents a historic meeting when instructor Keiko Fukuda from Japan made her first visit to the California Bay Area, sponsored by Helen Carollo, who was the instructor of Oakland Judo Club. From left to right are (first row) George Uchida, Tamo Kitaura, Helen Carollo, Keiko Fukuda, and Don "Moon" Kikuchi; (second row) Yosh Uchida, unidentified, Hideo Sato, ? Abe, and Mits Endo. (Courtesy of Dan Kikuchi.)

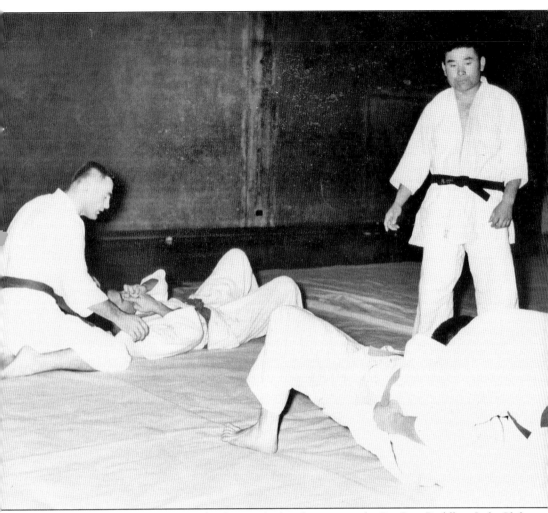

For over 40 years, Don "Moon" Kikuchi was the head instructor for San Jose Buddhist Judo Club, which has become one of the nation's largest of its kind. The club started in 1947 in a galvanized metal gym next door to San Jose Buddhist Church. It started as a club for Japanese Americans to work out after the war, as they were discriminated against, even in postwar from health clubs. Yosh Uchida remembers that it was really cold in the winter. Canvas wrestling mats filled with straw were donated by then San Jose High School wrestling coach, Sam Della Maggiore. The club then moved into the newly built church annex in 1961. In 1953, Don "Moon" Kikuchi was the 180-pound champion at the first US Amateur Athletic Union National Championships held in San Jose. Kikuchi was inducted into the US Judo Federation Hall of Fame Charter Class in 1993. (Courtesy of Dan Kikuchi.)

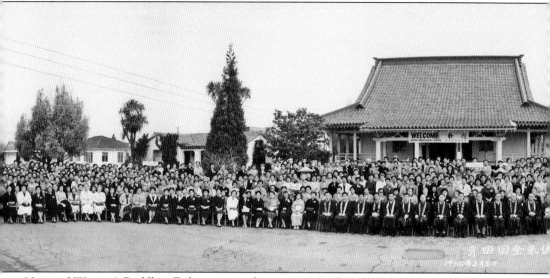

National Women's Buddhist Federation conference on March 6, 1960. Visible on the far right of the photograph are school buses that were used to pick up children from rural areas and bring

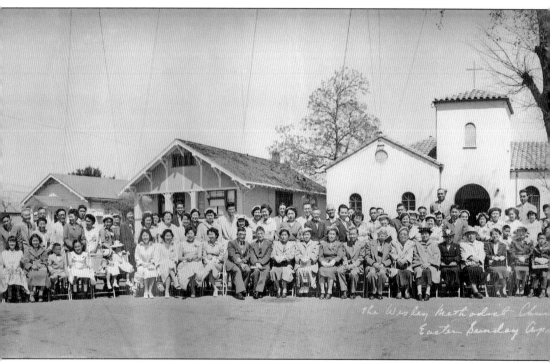

Wesley United Methodist Church members are pictured on Easter Sunday, April 10, 1955. Visible in this photograph are two homes on either side of the church. As the church continued to

them to church services on Sunday. They were also used to bring elderly Issei (first generation) members to the afternoon service. (Photograph by Utsumi, courtesy of Lee Uyeda.)

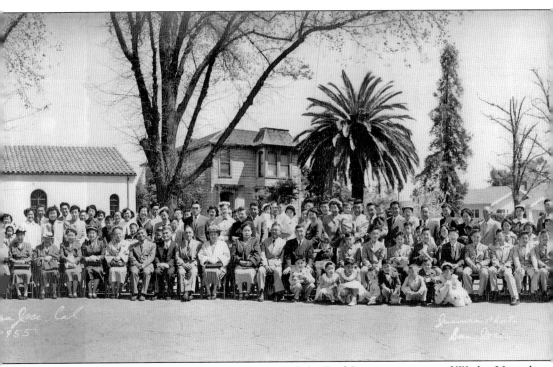

grow, these homes would be removed. (Photograph by Fred Jumura, courtesy of Wesley United Methodist Church.)

Bowling is another activity that the Nisei (second generation) and Sansei (third generation) really enjoy. The local bowling alley has several leagues that cater to Japanese Americans. There are several regional and national tournaments held each year. From left to right are Dr. Robert Okamoto, Tomoo Inouye, Machi Kumano (kneeling), James Hashimoto, and Dr. Tom Hiura. (Courtesy of Barbara Kawahara.)

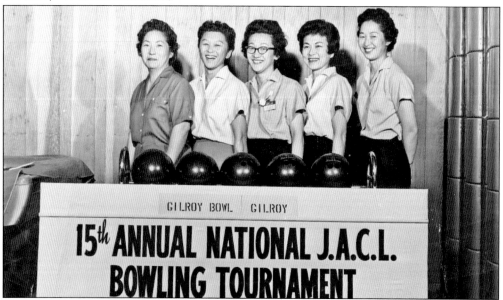

The 15th Annual National JACL (Japanese American Citizens League) Bowling Tournament in 1961 was held at Gilroy Bowl. The JACL was founded in 1929 and is the oldest and largest Asian American civil rights organization in the United States. (Donated by Mineko Sakai, courtesy of Japanese American Museum of San Jose.)

This is the younger Community Youth Service (CYS) baseball team in 1963. The team usually practiced at either Columbus Park or Bernal Park. From left to right are (first row) Raymond ?, Danny ?, Jeff Itatani, two unidentified, Larry Kubo, unidentified, Cort ?, and Grant Shimada; (second row) two unidentified, Danny Kikuchi, unidentified, Curt Fukuda, Franklin Abe, Gregory Taketa, Lester Santo, and Mori Shimada (coach). (Courtesy of Curt Fukuda.)

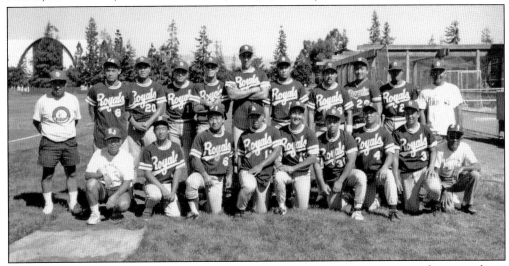

The San Jose Royals were formed in 1986. The team went on to win many championships, including the 1991 California State AA Baseball Championship. From left to right are (first row) Fred Watanabe (manager), Ryan Fujikawa, Gerald Ishimaru, Steve Sekimoto, Brian Iwashita, Chris Watanabe, Jason Matsuoka, Darren Kurose, and coach Roy Murotsune; (second row) coach Fred Kido, Lance Nakamitsu, Wes Tachibana, Aaron Tachibana, Kevin McCarsland, Todd Shimizu, Jim Wakayama, George Haruta, Reggie Higashi, Jeff Kong, and coach Rod Sekimoto. (Courtesy of Carolyn Watanabe.)

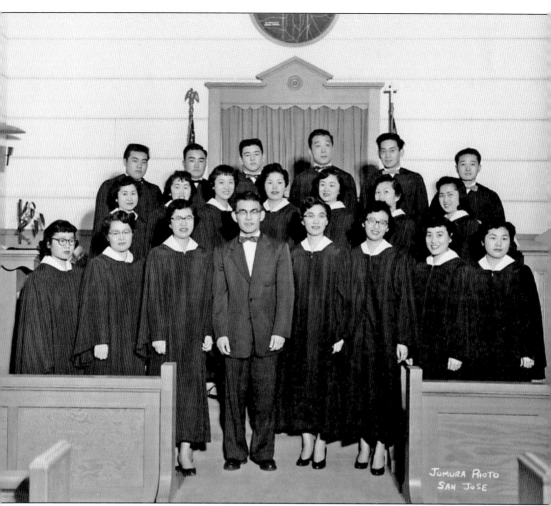

Ted Ashizawa organized the first choir at Wesley United Methodist Church in 1954. Here, the choir is practicing for Easter. From left to right are (first row) Michi Ino, Misao Hayashi, Alice Tanaka, Ted Ashizawa, Rose Nakano, Edith Kitajima, unidentified, and Shiz Konatsu; (second row) Sadie Furumasu, Helen Fujishin, Karen Tokunaga, unidentified, Elizabeth Kimura, Chiyo Uchiyama, and Gail Taketa; (third row) Mas Konatsu, Mas Konatsu, Norman Ashizawa, unidentified, Katsumi Hikido, and Sam Furumasu. (Photograph by Fred Jumura, donated by Sam Furumasu, courtesy of Japanese American Museum of San Jose.)

Katie Hironaka joined the Auxiliary of the San Jose Nisei Memorial Post 9970 in 1947. This photograph was taken in 1963 with the members wearing their uniforms. Many Japanese Americans volunteered for community activities because they wanted to show their loyalty to the United States. (Donated by Katie Hironaka, courtesy of Japanese American Museum of San Jose.)

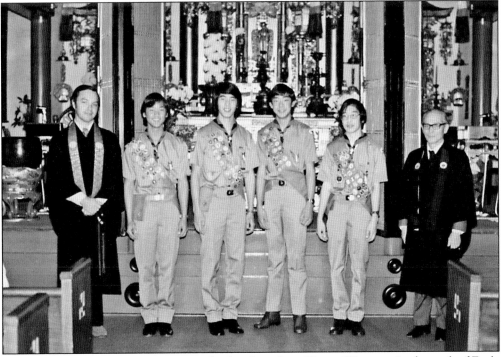

Pictured here on January 12, 1974, are the first boys from Troop 611 to attain the rank of Eagle Scout, the highest achievement in the Boy Scouts program. From left to right are Rev. Kenneth O'Neil, Mark Sakamoto, Ron Nakano, Chris Yamashita, Eric Morita, and Rinban Kyoshiro Tokunaga. (Courtesy of San Jose Buddhist Church Betsuin.)

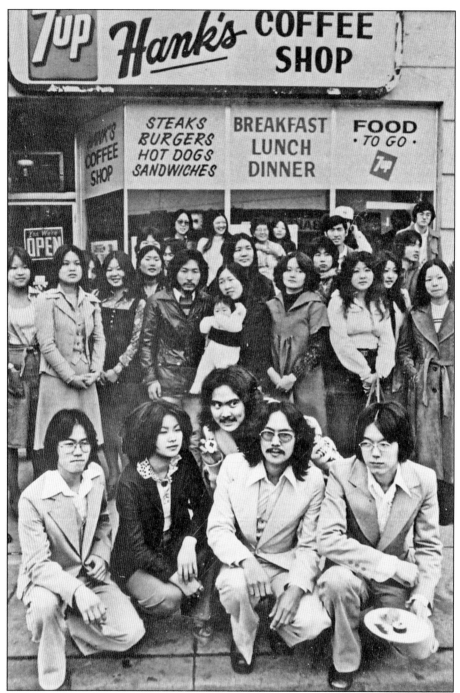

The Yokohama California album came out in March 1977, during a time when activism and personal identity were prevalent. The band wrote songs that encouraged Asian Americans to make positive changes in the community. The band members are seen here kneeling; from left to right are Keith Inouye, Sandra "Sam" Takamoto, Robert Kikuchi-Yngojo, Peter Horikoshi, and Michael Okagaki. Recently, the album was rereleased on CD with additional material. (Courtesy of Steve Yamaguma.)

A year after the original group photograph session, members of the Yokohama California band pose with their new album. This photograph was taken in front of Hank's Coffee Shop at 211 Jackson Street. (Courtesy of Steve Yamaguma.)

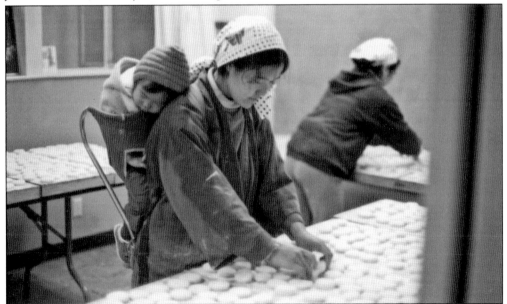

Sandy Wong and her daughter Ka'ohe are pictured at a *mochitsuki* (traditional rice-patty making) in 1978. The Asians for Community Action (ACA) started Yu-Ai Ki Community Center mochitsuki in 1971 as a way to stay in touch with their culture and to raise funds for the seniors. Mochitsuki usually occurs before the New Year and requires hundreds of pounds of rice and many volunteers. (Photograph by James Nagareda.)

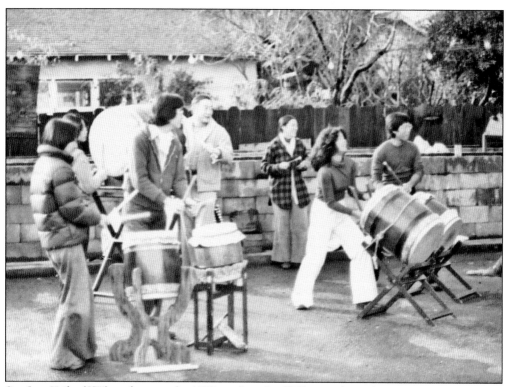

San Jose Taiko (SJT) performs at the 1978 mochitsuki. SJT has performed at numerous community events and concerts over the years. Their powerful performances always captivate and entertain the audience. (Photograph by James Nagareda.)

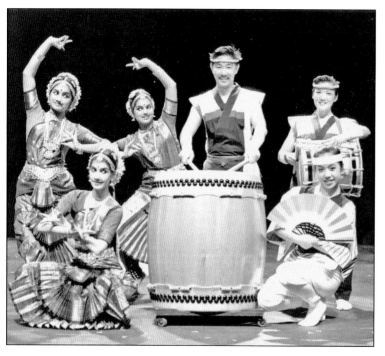

In addition to collaborating with Japanese artist, San Jose Taiko collaborated with artists from other disciplines. Abhinaya Dance Company was founded in 1980 by Mythili Kumar. They perform South Indian classical dance forms. Abhinaya Dance Company performers pose with SJT members, from left to right, Keith Morita, PJ Hirabayashi, and Anna Lin. (Photograph by James Nagareda.)

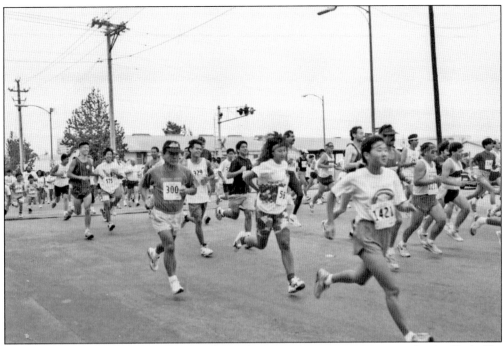

The Japantown Banner Run started in the mid-1980s as a way to raise money for the Yu-Ai Kai Community Center. Now called the Nihonmachi Run, it was originally established by Jeanne Katsuro and occurs prior to the annual Nikkei Matsuri Festival in the spring.

The Japantown Business Association used to sponsor a costume contest as part of the Nihonmachi Run, where the merchants would donate prizes for the best costumes. James Nagareda (on truck) and Amy Okagaki (with hat) award the Best Costume prize to this happy couple. (Both photographs courtesy of Japantown Business Association.)

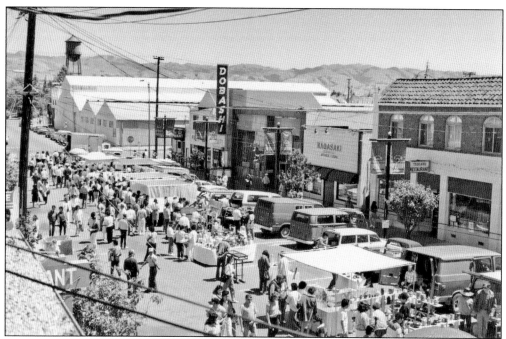

The Annual Nikkei Matsuri (Japanese American festival) started nearly 40 years ago when the City of San Jose encouraged ethnic groups to participate in the nation's bicentennial celebration in 1976. The following year, the first Nikkei Matsuri was started in order to promote and share Japanese American culture. The festival has grown to include crafts, food, and entertainment for the thousands of attendees to enjoy. Above are craft booths along Jackson Street at the 1978 Nikkei Matsuri, and below are food booths on Fifth Street at the same Nikkei Matsuri. (Both photographs by James Nagareda.)

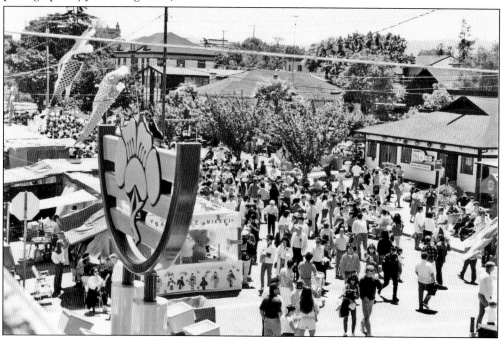

In 1987, the streets of Japantown were taken over by a crew filming a movie called *The Wash*. The movie featured Mako, Nobu McCarthy, and Sab Shimono. Filming took place at Fourth Street Pharmacy, Hank's Coffee Shop, and along Jackson Street. The corner of Kogura Company was magically transformed into Hasegawa's restaurant and Chiyo's Beauty Salon. Some local residents were used as extras. The movie was written by Philip Kan Gotanda. (Photograph by James Nagareda.)

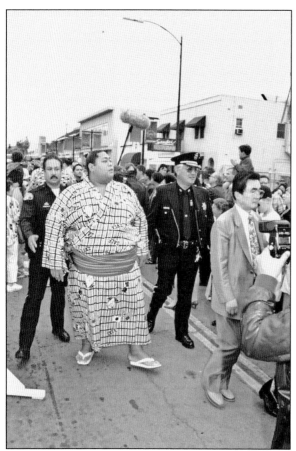

A sumo wrestler from Japan, Yasokichi Konishiki, walks down Jackson Street while being escorted by Chief Tom Shigemasa to the right. The sumo wrestlers were in town for the San Jose Sumo Basho in 1993. Born in Hawaii, Konishiki was the first non-Japanese to reach the rank of *ozeki*, the second highest rank in sumo. The sport of sumo originated in Japan and is considered a Japanese martial art. Sumo is a Japanese form of wrestling where a competitor tries to force his opponent out of the sumo ring or cause any part of his body to touch the ground, except the soles of his feet. (Both photographs by James Nagareda.)

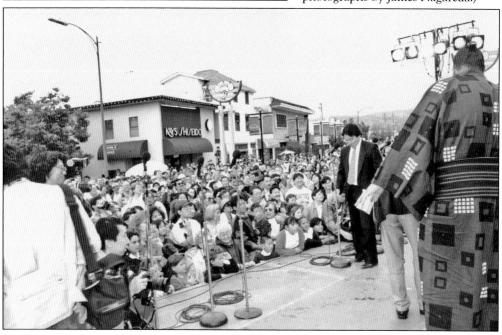

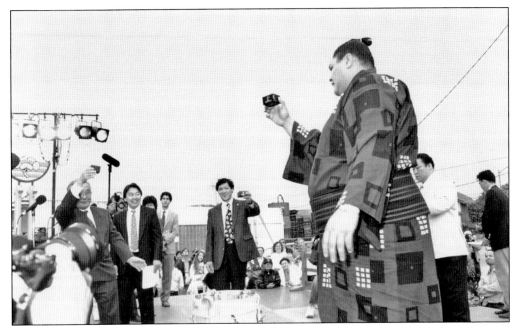

A special sake ceremony held at the intersection of Fifth Street and Jackson Street to celebrate the arrival of the sumo wrestlers (*rikishi*) to Japantown. Participating in the ceremony from left to right are Yosh Uchida, Robert Handa, Dale Yoshihara, and Taro Akebono. The first non-Japanese to attain the rank of *yokozuna*, the highest rank in sumo, Akebono was born in Hawaii. (Photograph by James Nagareda.)

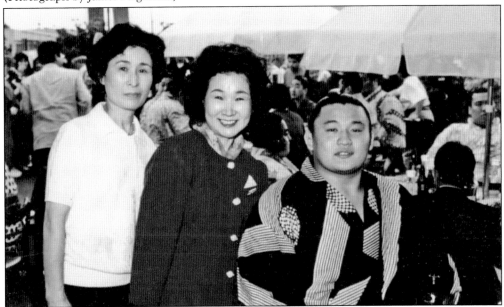

Sumo wrestlers are considered gods in Japan due to the ancient Shinto rituals that are practiced in sumo, along with their exceptional strength and skill. In this photograph, from left to right, are Chiyuki Higuchi, Kay Nagareda, and Takanohana Koji, who was the youngest to reach the top division at age 17. He would reach the highest rank of *yokozuna* in 1994. (Photograph by James Nagareda.)

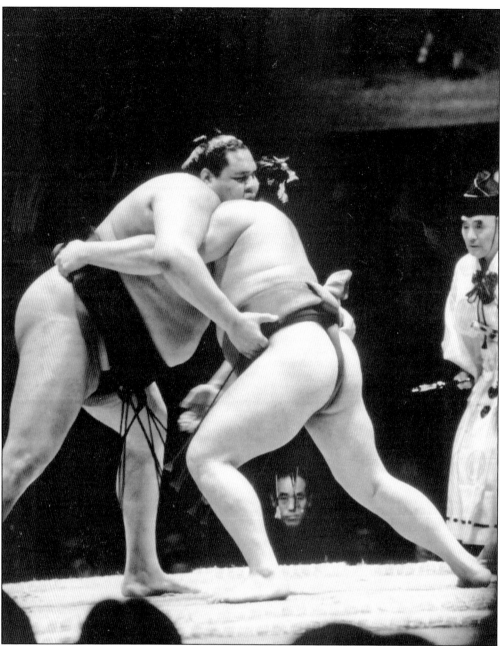

One of the most anticipated matches occurred at the San Jose Sumo Basho held at San Jose State University in 1993. Akebono Taro (left) and Takanohana Koji face off at the tournament, with Taro being the overall winner. Koji is considered small a six feet one inch and 340 pounds, whereas Taro is considered one of the tallest and heaviest *rikishi* at six feet eight inches and over 500 pounds. The sumo tournament came to San Jose in 1993 due to the efforts of Yosh Uchida, who was able to convince the Sumo Association to make the trip out here. It is interesting to note that the *rikishi* are considered national treasures. Given that, when they traveled to San Jose, the *rikishi* arrived in two separate planes. They do this in case there is an accident, which would be devastating to their national sport. (Photograph by James Nagareda.)

Four

COMMUNITY

The Ishikawa family celebrates Robert Ishikawa's birthday in 1938. From left to right are Tamaye Ishikawa, May (Shimoguchi) Ishikawa, Mitsuo Ishikawa, Nobukichi Ishikawa, Robert Ishikawa (sitting on Nobukichi's lap), Dr. Tokio Ishikawa, and Keiko (Koga) Ishikawa. The Ishikawa family was very involved in Japantown activities. Dr. Tokio Ishikawa lived in the area most of his life. He was born in Japantown in 1909 by a midwife, and his family owned a Dry Goods store on Jackson Street. Dr. Ishikawa was the first Nisei doctor and opened his office in the Kuwabara Hospital in 1937. He was the first historian of Japantown, and his recorded interviews give a firsthand view of early Japantown. (Courtesy of Jean Shimoguchi.)

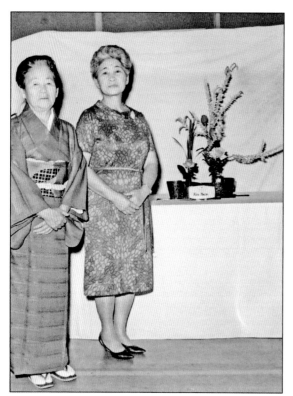

Kijiu Yoneda (left) and Kikue Uyeda pose next to Yoneda's ikebana display. Ikebana is the Japanese art of flower arrangement, which has been practiced for over 600 years. It is a disciplined art form where nature and humanity are brought together. (Courtesy of Yoneda family.)

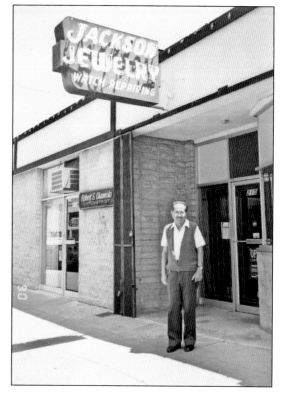

Bob Santo is pictured in front of his Jackson Jewelry store. Bob Santo, Hide Higuchi, and Frank Miyahara owned Jackson Jewelry, located at 246 Jackson Street. In 1963, Santo and Higuchi moved Jackson Jewelry to 210 Jackson Street and shared a building with Dr. Robert Okamoto optometrist and Aki's Bakery. Jeanne Katsuro bought Jackson Jewelry in 1990 and eventually changed the name to Classic Rock. (Courtesy of Bobbie Santo Shiraki.)

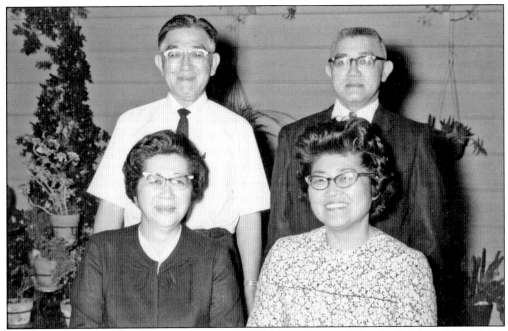

The Ishikawas are seen here in 1978. From left to right are (first row) Yoneko (Ishikawa) Morishita, and May (Ishikawa) Shimoguchi; (second row) Dr. Tokio Ishikawa and Mitsuo (Moffet) Ishikawa. (Courtesy of Jean Shimoguchi.)

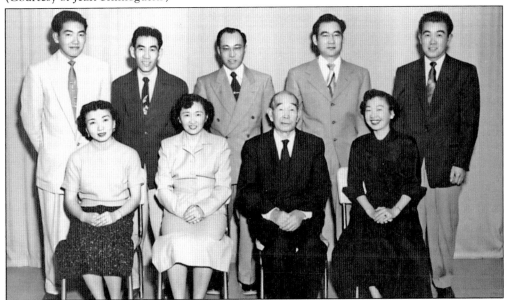

The Murotsune family are leaders in the community. From left to right are (first row) Emmy Nagareda, Mary Sachiye Murotsune (married to James Ishikawa and the "Mary" of Tom & Mary's Snack Shop), Yasaburo Murotsune, Lillie Yayeko Murotsune (married to Frederic Morita); (second row) Joe Masao Murotsune, Mark "Mike" Shigeru Murotsune (of Mike & Roy's), James S. Ichikawa, Tom Tamotsu Murotsune (the "Tom" of Tom & Mary's Snack Shop), and Roy Shigeto Murotsune (of Mike & Roy's and, later, Roy's Station). (Photograph by Fred Jumura, courtesy of Carole Rast.)

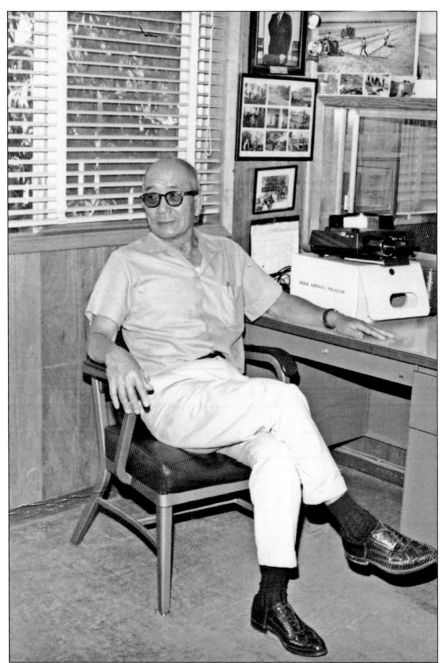

I.K. "Ishi" Ishimatsu is pictured in his office. He coordinated several farms that grew strawberry, tomato and citrus plants throughout California. Ishimatsu's family helped with the various farms that operated under the names of IKI Farms, I & M Farms, and Hi-Sierra Nursery. His plants were sold to growers and canneries in California. Besides being a smart businessman, Ishimatsu believed that the Japanese community needed to be involved in politics in order for it to be heard in government. He felt strongly that Japanese Americans should run for office and that the community should support candidates that could help them with their causes. (Donated by Dorothy Ishimatsu, courtesy of Japanese American Museum of San Jose.)

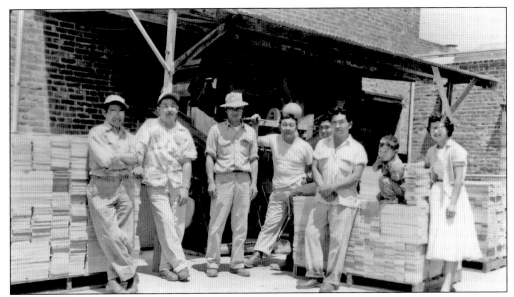

Here's a photograph of the work crew at Wayne Basket Co., just outside of Japantown in 1956. After the war, the company expanded to include fabricating wooden containers for vegetables and fruits. From left to right are Mits Honda, Sam Nagasaki, Carl Shimizu, Jim Y. Nishi, Isao Kondo, Frank Miyahara, Paul Shimizu, and Alice Hikido. (Donated by Esau Shimizu, courtesy of Japanese American Museum of San Jose.)

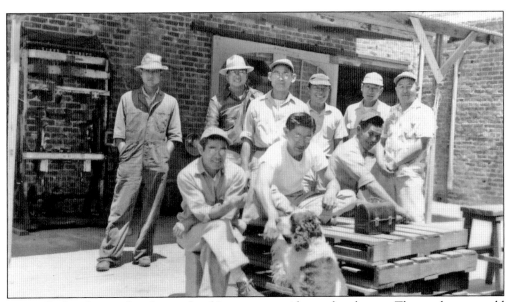

Wayne Basket Co. employed many local Japantown residents after the war. The employees would work for a short period of time until they could get their lives back in order. From left to right are (first row) Mits Honda, Fred Morita, and Yutaka "Moose" Nakamura; (second row) Carl Shimizu, Roy Shimizu, Sam Morihiro, Dee Abe, Grant Shimizu, and Sam Nagasaki. (Donated by Esau Shimizu, courtesy of Japanese American Museum of San Jose.)

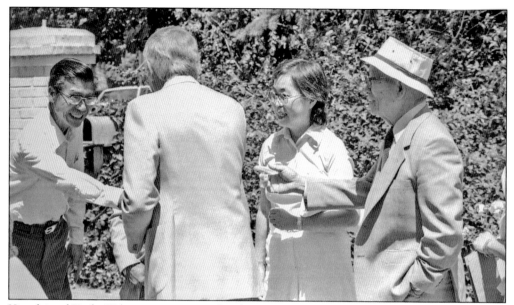

Kiyoshi and Kyoko Tokutomi are pictured with Congressman Don Edwards (back to camera) and I.K. Ishimatsu (far right). Kiyoshi Tokutomi was the San Jose assistant branch manager of the Hokubei Mainichi. Tokutomi also sponsored the JACL Mathematics Competition to encourage Japanese Americans to pursue careers in the sciences and engineering. In 1975, Kiyoko and Kiyoshi Tokutomi founded the Yuki Teikei Haiku Society (YTHS), one of the most important haiku organizations in the world. (Photograph by Curt Fukuda.)

Pictured from left to right, Ellen Reiko Bepp, P.J. Hirabayashi, and Linda Ito opened Earthenwear, which sold their line of Asian-influenced handmade clothing. All three were involved in Japantown culture and arts. (Photograph by Curt Fukuda.)

Mike Honda was born in 1941 in Walnut Grove, California. When he was one year old, he was sent to Camp Amache, the internment camp in Colorado. After the war, his family relocated in San Jose, where they became strawberry sharecroppers. After graduating from San Jose State with a master's degree in education, Honda would work in education for 30 years. In 1971, San Jose mayor Norman Mineta appointed Honda to the city's planning commission. Honda would continue his career in politics when in 2000 he would win the Democratic nomination for the 15th District. Throughout Honda's career, he has always been supportive of the Japantown community. He can frequently be seen at local events. (Above, courtesy of Mark Briggs Collection; left, courtesy of Mike Honda.)

If there is one person that one could never run out of nice things to say about, that would be Jimi Yamaichi. He has been active in the community for decades. One day, he might be helping the Boy Scouts, and another day he will be making something at the museum. He has a big heart and was very supportive when Curt Fukuda and James Nagareda wanted to work on a Japantown history project. Yamaichi provided financial help and encouragement to help get the project started. He also helped to connect Fukuda and Nagareda with the Issei and Nisei that would provide the content for the book. Yamaichi has also served on the Japantown Board of Directors for several terms and has helped to start some of the most iconic events and organizations. In the photograph at left, Yamaichi can be seen at the Nikkei Matsuri Festival. The photograph below was taken in 1987 and shows, from left to right, Jimi Yamaichi, Norman Mineta, and Warren Hayashi. (Left, photograph by James Nagareda; below, photograph by Curt Fukuda.)

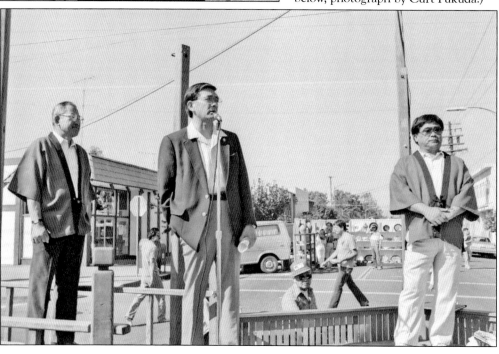

The highlight of the annual Obon Festival is the *odori* (dancing), where hundreds of people dress in their colorful kimonos. From left to right are (first row) Rinban Kenshin Fujimoto and Hanayagi Reimichi, Reiko Iwanaga; (second row) Eileen Sera, Judy Santo, Cindy Iwamura, and Bando Misayasu, Mary Arii Mah; (third row) Karen Akimoto, Gail Sueki, and Diane Tsukamoto Hurd. (Photograph by James Nagareda.)

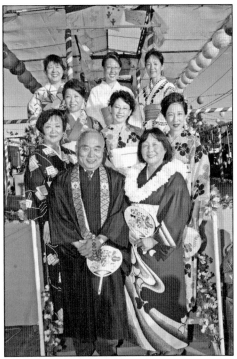

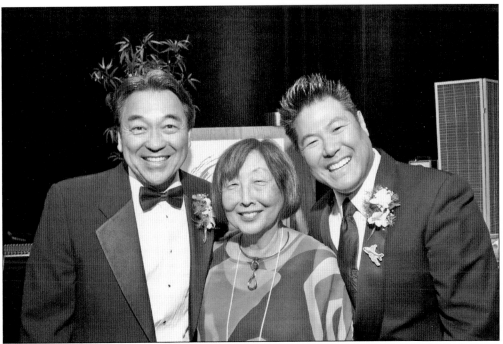

Reiko Iwanaga (center) is pictured with master of ceremonies Robert Handa (left) and Mike Inouye. Not only is Reiko Iwanaga the lead instructor of the Obon Festival *odori*, she is also very active in the Japantown community. In most cases, Iwanaga is behind the scenes at many community events as an event planner. She is able to juggle many tasks at one time, and the events that she works on are always professionally produced. (Photograph by James Nagareda.)

On November 12, 1931, Norman Mineta was born to Kunisaku and Kane Mineta. Norman Mineta went to San Jose High School, then graduated from University of California, Berkeley, School of Business Administration. After serving in the US Army, Mineta went to work with his father at his insurance agency at 170 Jackson Street, where Jimbo's ice-cream shop is now located. In 1967, Mineta was appointed by Mayor Ron James to the San Jose City Council to fill a vacant seat. In 1969, he was voted into office and elected to be vice mayor by the other council members. Mineta was then elected mayor of San Jose in 1971 and became the first Japanese American mayor of a major city. From 1975 to 1995, he sat in the US House of Representatives. Most recently, Mineta served as the US secretary of transportation in Pres. George Bush's cabinet until 2006. (Both photographs courtesy of Japanese American Museum of San Jose.)

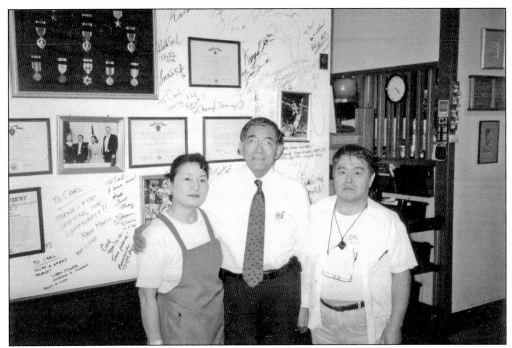

Norman Mineta (center) is pictured with Michiko and Carl Hirano, owners of the Ginza Café, which opened in 1957 at 215 Jackson Street. It served Japanese food for two decades and featured a wall of autographs from sports stars, movie stars, and politicians like (then) Secretary of Transportation Norman Mineta. (Courtesy of Carl Hirano.)

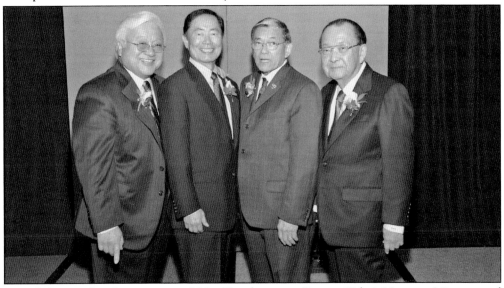

From left to right, Congressman Mike Honda, actor George Takei, Norman Mineta, and Sen. Daniel Inouye attend a tribute dinner honoring Mineta. Norman Mineta received many honors for his years of service following his resignation from politics in 2006. Mineta received the Presidential Medal of Freedom, the nation's highest civilian honor. The following year, he received the Grand Cordon, Order of the Rising Sun from the Japanese government. (Photograph by James Nagareda.)

Tomoo Inouye operated Fourth Street Pharmacy at the corner of Jackson Street for over 40 years. His shop had a popular lunch counter, pharmacy, and the only post office in Japantown. Inouye loved to fish and would try to go fishing every week. He was very active in the Japantown Business Association. (Courtesy of Inouye family.)

Henry "Hank" Nishijima is pictured with a big catch. In 1965, Nishijima opened Hank's Coffee Shop at 211 Jackson Street. An avid fisherman, he opened Hank's Rod and Reel after closing his coffee shop. For many years, Hank's Coffee Shop and several other locations in Japantown were popular hangouts with friendly backroom poker games. (Courtesy of Nishijima family.)

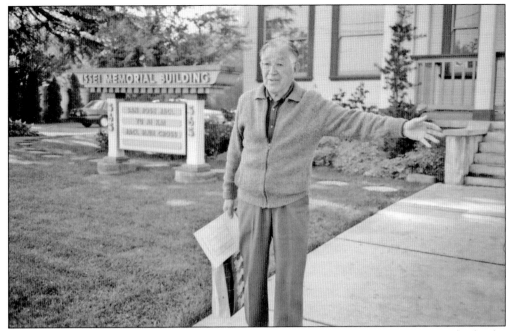

Dr. Tokio Ishikawa lived nearly his entire life in San Jose Japantown. A community leader, he became one of the first Japantown historians, giving talks and leading walking tours from the 1980s until he passed in 1997. (Photograph by Curt Fukuda.)

Photographer Pat Itatani shows off one of the panoramic photographs that he took of a Japantown group. During the 1950s and 1960s, Itatani would take the photograph, rush home to develop the film, and make prints using a bathtub. He would hurry back to Japantown to deliver prints that same day or the next day. (Photograph by James Nagareda.)

Dr. Jerrold "Jerry" Hiura started working with father Dr. Thomas Hiura's dental office that was opened in 1954. Eventually, Jerry took over the dental practice and recently moved to a new building on Taylor Street that was previously owned by Attorney Peter Nakahara. Jerry is very active in the arts community as a founding member of CATS (Contemporary Asian Theater Scene), and he was appointed to the California State Arts Council. (Courtesy of Japantown Business Association.)

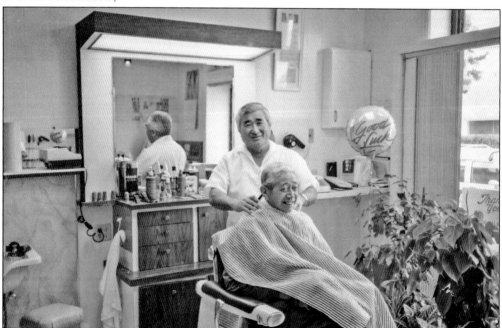

There were several barber shops in Japantown, including Sakamoto's Barber Shop on Sixth Street. Next to Minato Restaurant, Sakamoto's was also one of the last places where people went to play a friendly game of cards. (Courtesy of Japantown Business Association.)

Art Kumada is pictured with his two daughters Karen and Kathy (standing) and their cousin in front of the Buddhist church in 1951. When the Kumadas moved to a strawberry farm, a bus from the San Jose Buddhist Church would pick up the girls every Sunday and take them to Dharma School. (Donated by Art Kumada, courtesy of Japanese American Museum of San Jose.)

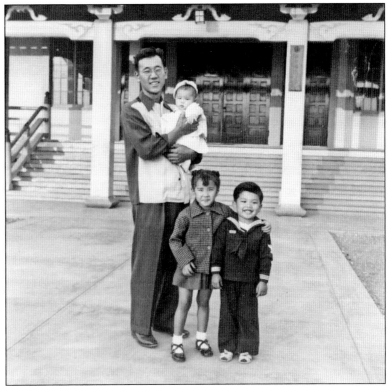

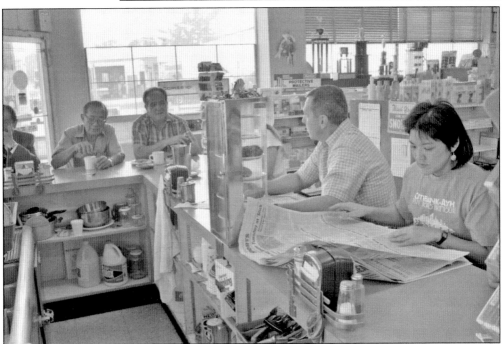

Lunch counters have been popular locations for people to hang out, drink coffee, read the paper, and talk about the day's news. This is the counter at Fourth Street Pharmacy. (Photograph by Curt Fukuda.)

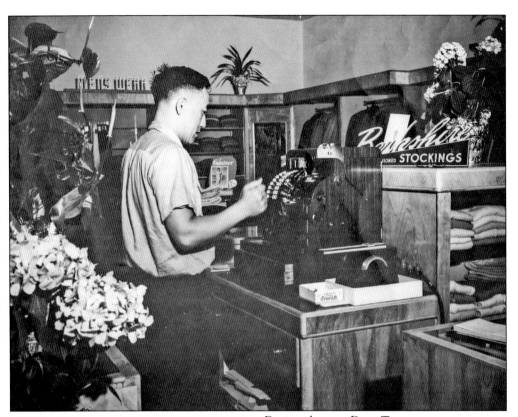

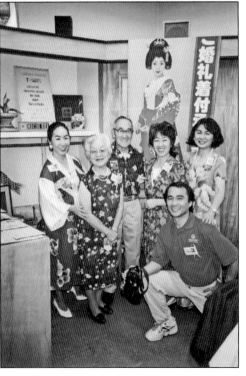

During the war, Dave Tatsuno was sent to the internment camp in Topaz, Utah. The Tatsuno family stayed behind barbed wire from May 1942 to May 1945. Although forbidden, Dave Tasuno was able to take 8mm movies of the life inside the camp. His film *Topaz 1945* was inducted into the 1996 Library of Congress's film registry. This was a huge honor, since it was only the second home movie to be selected. The other home movie was of the John F. Kennedy assassination. Dave Tatsuno opened the San Jose branch of Nichi Bei Bussan in 1948. Above, Dave Tatsuno is seen working at the store in the 1950s. Below, the Tatsuno family celebrates the 50th anniversary of the San Jose location. From left to right are Valerie, Alice, Dave, Arlene, Melanie, and Sheridan (front). (Both photographs courtesy of Tatsuno family.)

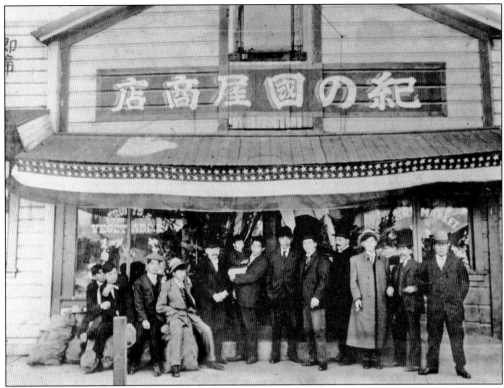

Established on Jackson Street in 1912, Dobashi Market was originally called Kinokuniya (pictured above). By 1935, the old wooden structure was replaced by a stucco building, now occupied by Tsugaru Restaurant. This building had the store on the first floor and living quarters above. Despite hard economic times and their forced removal during the war, Dobashi Market did well enough to survive. In fact, by 1955, they were able to buy the property two doors down at 240 Jackson Street and erected a new building constructed out of glass and steel. With increased competition from large chain stores that now maintain a small Asian section, Dobashi closed its doors on January 1, 2006. (Above, courtesy of Japanese American Museum of San Jose; below, photograph by Curt Fukuda.)

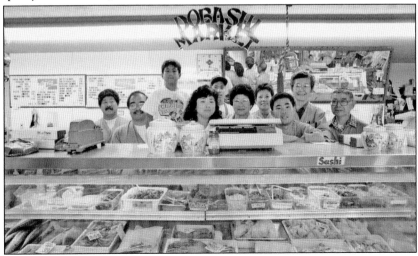

Two of the hardest-working people in Japantown can be seen here at a San Jose Buddhist Church New Year's Party in 2003. George Hanada (left) and Jimi Yamaichi can always be seen fixing this or building that. Hanada owned and operated George's Service Center at the corner of Fourth and Jackson Streets for many years. (Photograph by James Nagareda.)

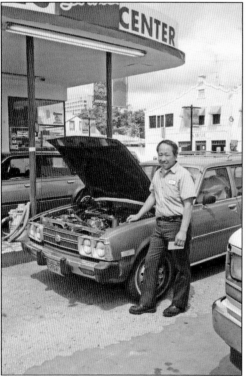

Fred Kido purchased George's Service Center from George Hanada. Kido continued working on cars, even after a few nearby shops closed. He eventually sold the service center to Marco Aning, and the name was changed to San Jose Autoworks. (Courtesy of Japantown Business Association.)

The Konko Church of San Jose is located at 284 Washington Street, just outside of Japantown. Rev. Haruko Ishiwata (pictured in front) took over head minister duties at Konko Church of San Jose after her mother, Rev. Fusa Yamada passed away in 1978. Rev. Haruko Ishiwata's son Rev. Byron Ishiwata (in back) received his credentials in 1993. In 2005, he would become the head minister after his mother suffered a stroke. (Photograph by Curt Fukuda.)

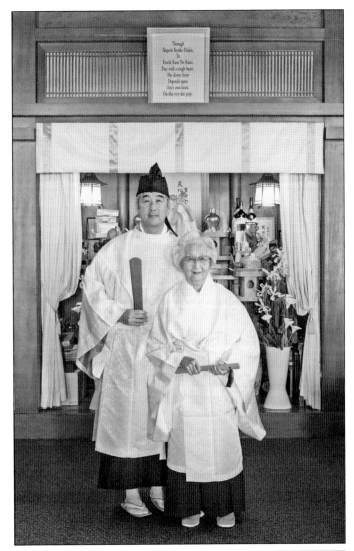

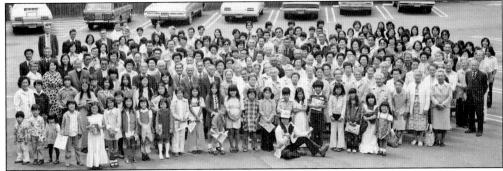

Members of the Wesley United Methodist Church congregation are pictured on May 30, 1976. The church celebrated its 80th anniversary on October 25, 1975. That year, they published the revised version of their cookbook *Our Treasured Recipes* and sold 19,000 copies. (Courtesy of Wesley United Methodist Church.)

Dr. Robert Okamoto and his wife, Fujiko, who worked for Japantown physician Dr. Morton Kimura. Dr. Okamoto opened his optometry business on Jackson Street in the late 1940s. Jim Hashimoto asked Dr. Okamoto if he wanted a space in his new building, and he accepted. His business partner, Dr. Tina Shinmori, has taken over daily operation, but Dr. Okamoto's sign still hangs on the outside of the building. (Courtesy of Barbara Kawahara.)

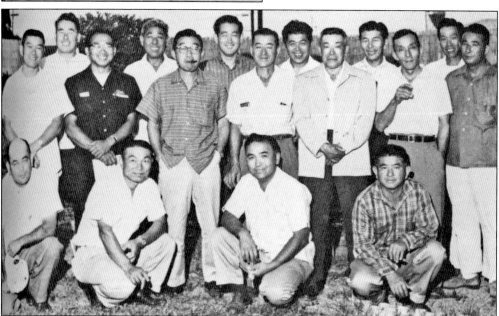

This is a photograph of the 1964 San Jose Landscape Gardener's Association convention committee. There were many Japanese gardeners in the 1950s and 1960s. In fact, most of the members of the San Jose Landscape Gardeners' Association were Japanese. Their office was located in the Soko Hardware Building in Japantown. (Courtesy of Lillie Morita.)

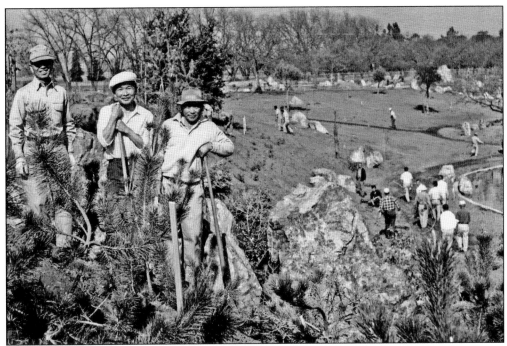

The Japanese Friendship Garden in San Jose was built by the hard work of the San Jose Landscape Gardeners' Association and their friends. Dedicated in 1965, the garden is designed after the famous Korakuen Garden in Okayama, Japan. In 1966, San Jose's sister city, Okayama, sent koi to stock the three ponds at the garden. Besides the Japanese Friendship Garden, the San Jose Landscape Gardeners created the garden at the San Jose Buddhist Church Betsuin and Sumitomo Bank, now California Bank and Trust on North First Street. (Both photographs courtesy of Reiko Iwanaga.)

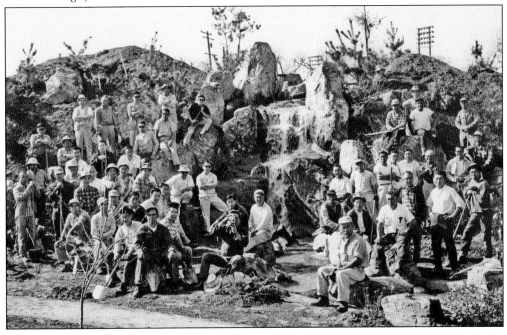

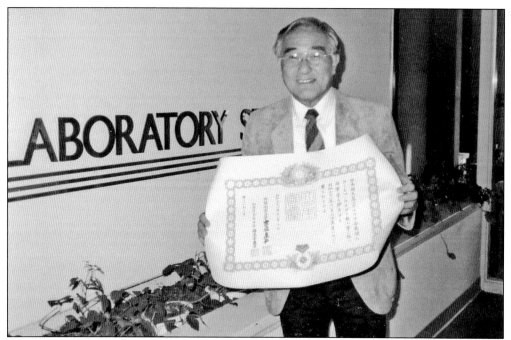

Yoshihiro "Yosh" Uchida is pictured with his Order of the Sacred Treasure with Golden Rays certificate from Emperor Akihito of Japan. The Order of the Sacred Treasure is awarded to those who have made distinguished achievements in research fields, business industries, healthcare, social work, state/local government fields or the improvement of the lives of handicapped persons. (Courtesy of Uchida family.)

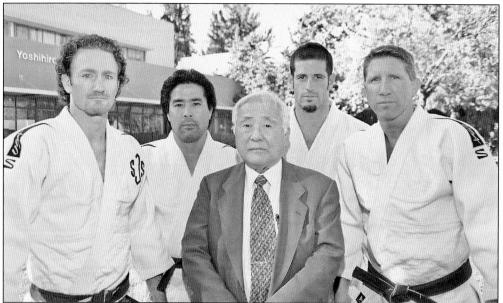

In this photograph, judo coaches surround Yosh Uchida. From left to right are Chuck Jefferson, Keith Nakasone, Uchida, Eitan Gelber, and Mike Swain. To this day, Uchida attends judo practice every day at Uchida Hall at San Jose State University. Uchida has coached several Olympic medal winners, including Mike Swain. (Photograph by James Nagareda.)

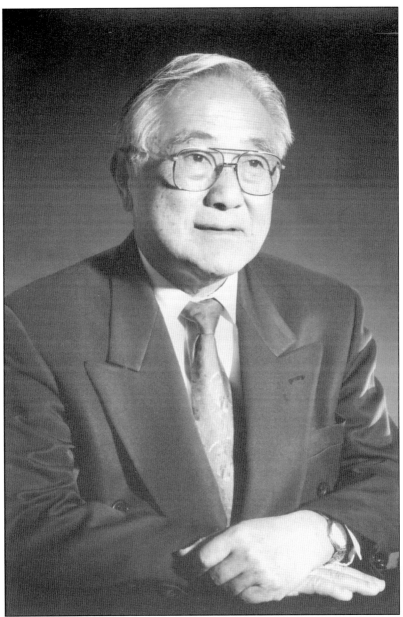

Yosh Uchida is an entrepreneur, advocate, and judo icon. Born in 1920, in Orange County, Uchida was picking strawberries on his family's farm when he decided to go back to college in order to have a better life. He moved up to San Jose in 1940 and attended San Jose State University (SJSU), where he studied chemical engineering. After serving in the military during World War II, Uchida changed his major to biological science. At the same time, he was appointed the student coach for judo at SJSU. He eventually got a couple of jobs before ending up at San Jose Clinical Lab, which he ended up purchasing then expanding to 40 medical laboratories. In addition, Uchida has been an advocate for Japantown and Japanese American issues. Whether it is a housing project in Japantown or supporting a local politician, Uchida is usually involved in some way. To this day, no matter how busy he may be, Uchida will pick up the phone and personally call his friends to keep them updated on current issues. (Photograph by James Nagareda.)

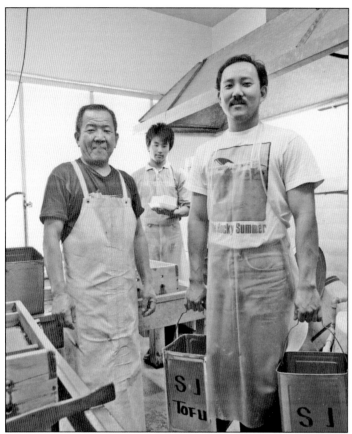

Throughout the history of Japantown, there have been several tofu shops. The only shop that exists today is San Jose Tofu, owned by Chester and Amy Nozaki. Originally started in 1946 by Heisho Marumoto, Chester's grandfather Yoshizo Nozaki and father Takeshi "Ken" Nozaki operated the business before handing it down Chester and Amy. San Jose Tofu is located at 175 Jackson Street in a building that is owned by the Murotsune family. Like several of the old buildings, there are living quarters that are adjacent to and behind the business. In addition, if viewing the side of the building, it looks like a house with a flat facade in the front. (Left, photograph by Curt Fukuda; below, photograph by James Nagareda.)

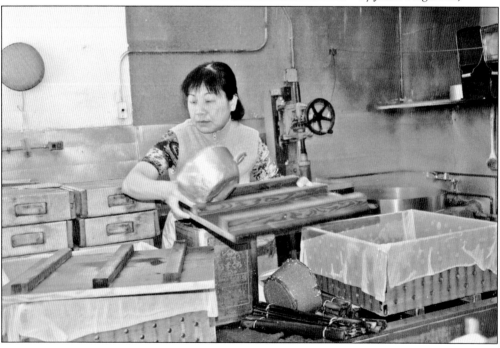

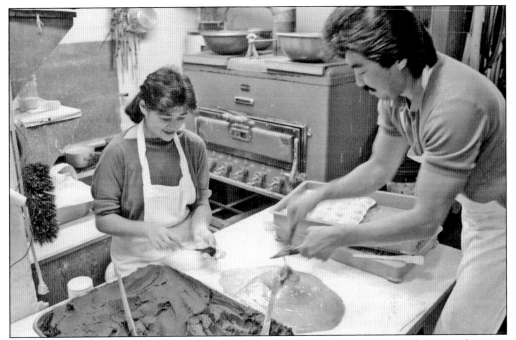

Manju is a popular Japanese confection. There are many varieties of manju, but most have an outside made from flour and rice powder and a filling made from red bean paste. Manju is a dessert that is served at special occasions and holidays or eaten any day as a special treat. The process of making manju is very labor intensive and repetitive, under hot and humid conditions. Tom and Judy Kumamaru continue the tradition of making manju that was taught to them by John and Hatsuyo "Sue" Ozawa, who opened the shop in 1951. The Kumamarus bought the shop in 1986 and continue making these sweet desserts to the delight of their customers. Shuei-Do Manju Shop in Japantown is considered to have the best manju in the world. (Above, photograph by Curt Fukuda; below, photograph by James Nagareda.)

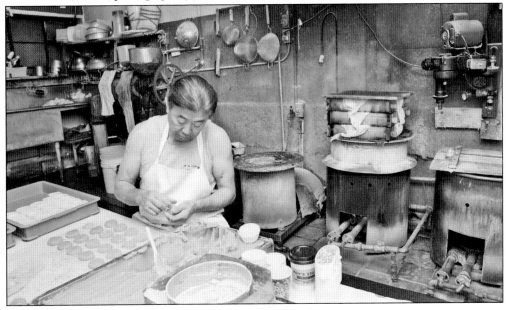

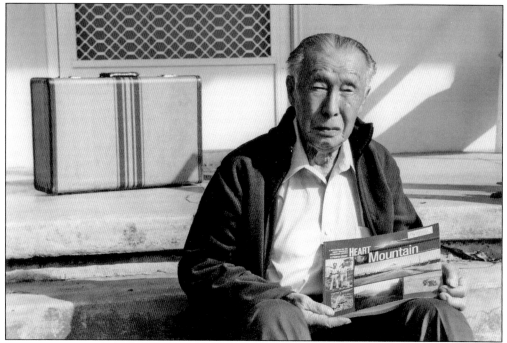

Eiichi Sakauye is pictured with his book about Heart Mountain internment camp. In 1999, Sakauye purchased the home of Dr. Tokio Ishikawa and donated it as a permanent location for Japanese American Museum of San Jose (JAMsj). There is a permanent exhibit at JAMsj that features farming equipment from the Sakauye farm. Eiichi Sakauye learned how to operate a farm from his father, Yuwakichi Sakauye, who owned property on North First Street and Trimble Road. (Photograph by James Nagareda.)

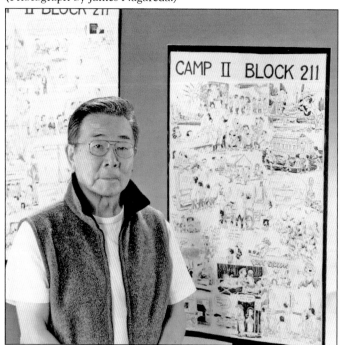

Cartoonist Jack Matsuoka is known around the world for his cartoons. He is especially known for his book, *Poston Camp II: Block 211*, which features cartoons he drew while in an internment camp in Poston, Arizona. Matsuoka's cartoons could also be seen regularly in the *Hokubei Mainichi* newspaper during the 1960s and 1970s. (Photograph by James Nagareda.)

Hideo Kamimoto was the first person to write a how-to book on fixing guitars, called *The Complete Guitar Repair*. He repaired guitars for many professional musicians, including John Fogerty. Kamimoto has retired, but the business he owned on Fourth Street remains today. (Photograph by James Nagareda.)

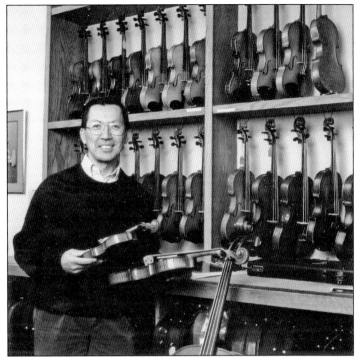

Nikkei Tradition owners James Nagareda (far right), Juli Tachibana (left) and Pam Yoshida (third from the left) pose with ukulele master Jake Shimabukuro. Paul Osaki and Kyle Tatsumoto, who opened Nikkei Traditions in San Francisco, encouraged Nagareda to open a San Jose location. The San Jose store opened in November 2001 to take advantage of the upcoming holiday. (Courtesy of Nikkei Traditions.)

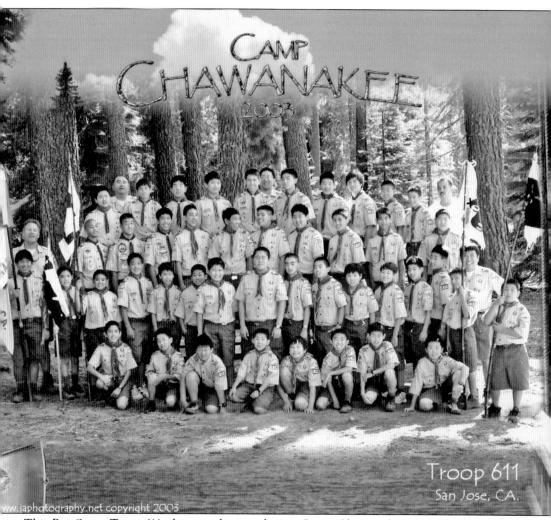

This Boy Scout Troop 611 photograph was taken at Camp Chawanakee in 2003. From left to right are (first row) Steven Nichols, Ryan Seid, Davey Nara, Kirk Akimoto, Andrew Knaack, Brandon Nakayama, Ryan Ichinaga, Tyler Shiramizu, and Jeff Doi; (second row) Eric Tanizawa, Conor McClure, Alex Mock, Alex Kadokura, Garrick Hirasawa, Trevor Ogata, Kyle Nodohara, Aki Matsumoto, Kenny Iyoya, Mark Akizuki, Thomas Shinagawa, Eric Beutler, Craig Akimoto, Kevin Onishi, Eric Takemoto, and Steve Doi; (third row) Brian Beutler, Kirk Hiroshima, Eric Nakagawa, Doug Sakamoto, Garrett Katashima, Mike Doi, Adam Mock, Eric Higashi, Tyler Hirasawa, Tyler Nii, and Alex Santo; (fourth row) Russell Takehara, Stan Kawamata, Scott Nichols, Kole Tanouye, Braden Hirasawa, Mitchell Beutler, Art Shinagawa, Ryan Santo, Jordan Fujioka, Jerry Knaack, Grant Kadokura, Tyler King, and Martin Iyoya. (Photograph by JA Photography, courtesy of Joanne Mock.)

106

Five

CONTEMPORARY
JAPANTOWN

The corner of North Fifth Street and Jackson Street is considered the center of Japantown.
(Photograph by James Nagareda.)

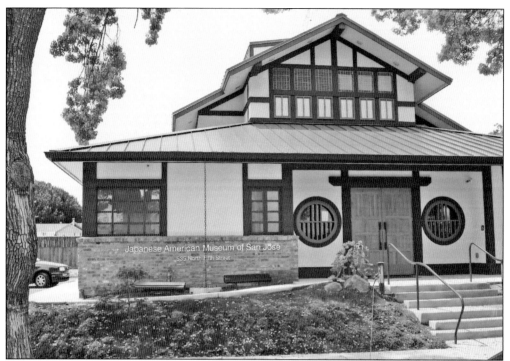

The Japanese American Museum of San Jose started out as the Japanese American Resource Center (JARC) and rented rooms in the Issei Memorial Building. Needing more space and a permanent location, Eiichi Sakauye bought the former home of Dr. Tokio Ishikawa and donated it to JARC. In 2002, the name was changed to Japanese American Museum of San Jose. (Photograph by Ralph Pearce.)

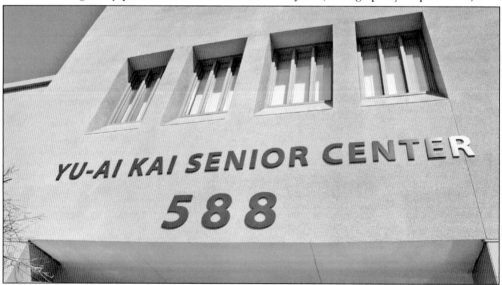

Opened in 1974, Yu-Ai Kai was originally called the Japanese American Community Senior Service of San Jose (JACSS). In future years, the name was changed to add Yu-Ai Kai to the front of the name. Yu-Ai Kai means "Friendship Love Association." When Yu-Ai Kai wanted to build a new building, Dr. Wright Kawakami, Ken Iwagaki, and Yosh Uchida agreed to be guarantors on the construction loan. (Photograph by James Nagareda.)

Originally the Kuwabara Hospital, located at 565 North Fifth Street, the Issei Memorial Building (IMB) is another iconic Japantown building that was built by the Nishiura Bros. Construction Co. The San Jose Japanese American Citizens League (SJ JACL) set up their office in the IMB postwar. The SJ JACL was instrumental in helping families when they returned from internment. Currently, the IMB has several tenants that includes; SJ JACL, San Jose Taiko, Contemporary Asian Theater Scene, and others. Built in 1910, the IMB is a Historic Landmark registered with the City of San Jose. (Photos by James Nagareda.)

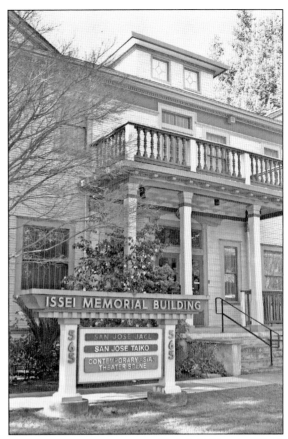

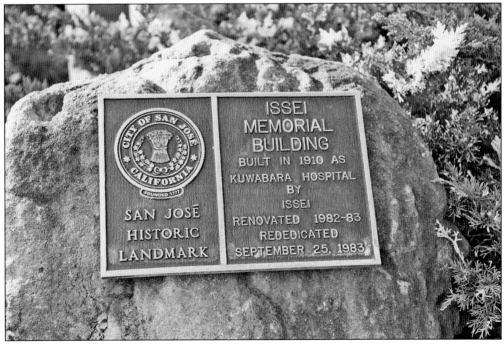

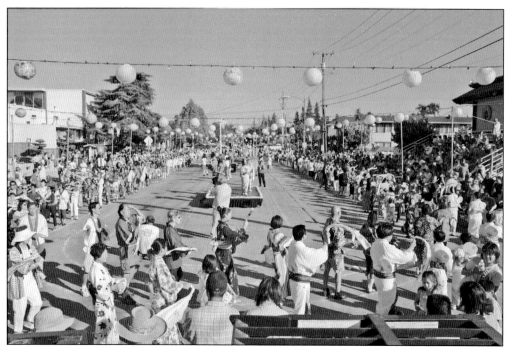

The San Jose Obon festival is a Buddhist custom to honor the spirits of one's ancestors. Many people in Japan return to ancestral family places to be with their family. For over 500 years, the *obon* has been celebrated traditionally with a dance called an *obon odori*. Since the festival occurs in the summer, the dancers traditionally wear yukata, or light kimonos. The San Jose Obon is the largest festival in Japantown. It features food, games, entertainment and *odori* over a two-day weekend in July. The proceeds from the festival go to the operating expenses of the San Jose Buddhist Church Betsuin. (Both photographs by James Nagareda.)

The Miraido Village Apartments are at 566 North Sixth Street, the former location of the first Asahi Baseball Field, where Sumo tournaments were also held. There have been a few new housing developments in the Japantown area. They have mostly been high-density housing with some retail below. The Japantown area is an attractive place to live, partly because it is located in the "Golden Triangle" area. It got this distinction because it is surrounded by the three major freeways that serve San Jose. (Photograph by James Nagareda.)

There have been several doctors that have served the Japantown community. The last remaining doctor is Dr. Chiu Yuan on First Street, who will probably retire soon. Luckily, Yosh Uchida convinced his friend Dr. Bob Nishime to relocate from Chicago and set up his practice in Japantown. The community welcomed Dr. Nishime with open arms, and he has been a big asset to the community. (Photograph by James Nagareda.)

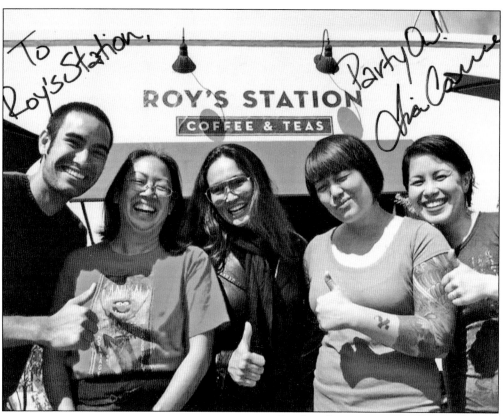

San Jose Japantown gets a fair number of celebrity visitors. Here, the Rast family poses with musician/actress Tia Carrera in front of Roy's Station at the corner of Fifth Street and Jackson Street. From left to right are Miles Rast, Carole Rast, Carrera, Tamiko Rast, and Jasmine Rast. (Courtesy of Rast family.)

The Yoneda family poses with Anthony Bourdain after he filmed an episode of his show at Minato Japanese Restaurant. Many celebrities, musicians, and politicians call Minato their favorite hangout. From left to right are Christin Yoneda, Gene Yoneda, Bourdain, Cassidy Yoneda, and Jo Ann Yoneda. (Courtesy of Yoneda family.)

Jeanne Katsuro is seen here in Jackson Jewelry store at 210 Jackson Street. Katsuro bought the Jackson Jewelry store from Bob Santo in 1990. She eventually changed the name to Classic Rock and moved to a bigger space at Miraido Village. (Courtesy of Jeanne Katsuro.)

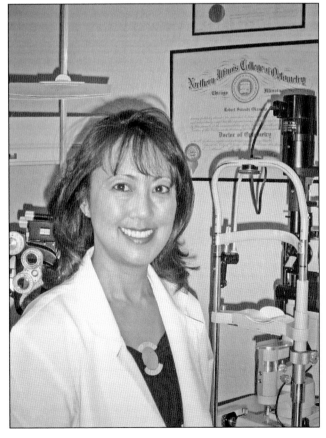

Dr. Tina Shinmori is part of a wave of young professionals that are now operating a business in Japantown. Dr. Shinmori had partnered with Dr. Bob Okamoto in his optometry business. After Dr. Okamoto's retirement, Dr. Shinmori took over the practice with the help of her father, Bill Shinmori. (Photograph by Bill Shinmori.)

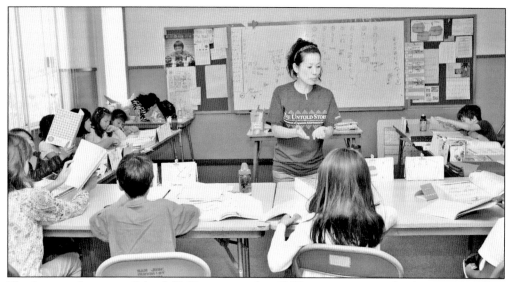

The Japanese Language School (JLS) was started in 1907 as an activity at the San Jose Buddhist Church Betsuin to meet the needs of Japanese immigrants. In 1911, the church also sponsored Japanese classes in the Berryessa Road area, and in the 1930s, there were classes in Los Gatos. Now, the JLS is for anyone that wants to learn Japanese and Japanese culture. Classes meet every Saturday at the San Jose Buddhist Church Betsuin. All ages are welcome. The instructor pictured here is Yoko Kobashi. (Photograph by James Nagareda.)

The fourth generation of the Santo family works at Santo Market, located at 245 East Taylor Street. For small mom-and-pop stores, their family plays an important part in the success of the business. Pictured from left to right are (sitting) Carly Yamaichi, Aly Yamaichi, Madison Santo, Kylie Santo, Trisha Yamaichi, and Trent Santo; (standing) Helen Santo, Sydney Santo, Marissa Kitazumi, Earl Santo, and Mitchell Kitazumi. (Courtesy of Santo family.)

The Sushi Shark was created by Doug Wright as part of a citywide art exhibit featuring different artists' renderings of the same shark. The decorated sharks were placed all around town for several weeks. A shark was chosen as the theme because of San Jose's professional hockey team, the San Jose Sharks. (Photograph by James Nagareda.)

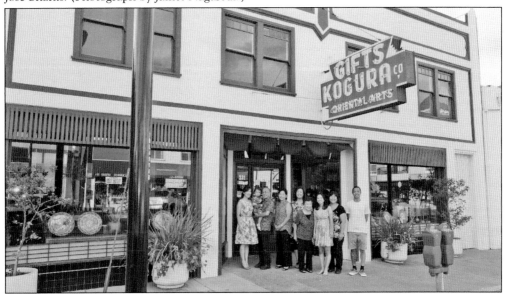

Established in 1928, Kogura Gifts is the successor business of Sashi Food Company. In 1934, Kohei Kogura acquired Sakura Shoten and moved the business to the current location. Today, it is going strong with Carolyn Kogura (third generation) handling the day-to-day operations. From left to right are Tracie (granddaughter), Adelaine (great-granddaughter), Richard (son), Cindy (daughter-in-law), Patty (daughter), Toshiko (wife), Julie (granddaughter), Carolyn (daughter), and Jimi (grandson). (James Kogura family photograph, courtesy of Richard Kogura.)

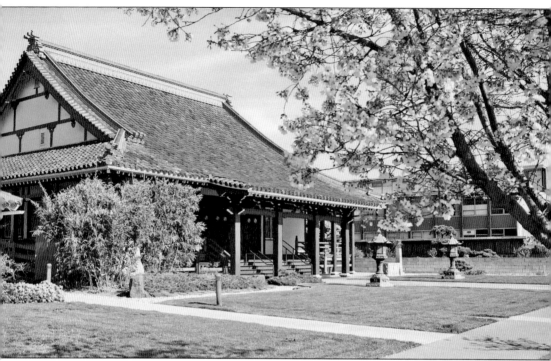

The San Jose Buddhist Church Betsuin is one of the most iconic and beautiful buildings in Japantown. It continues to serve the community with weekly Sunday services, Japanese Language School, Scouting programs, Lotus Preschool, and other church-related activities. Additionally, several groups such as the Buddhist Judo Club and those focused on kendo, ikebana, and bonsai use the facility for their activities. (Photograph by James Nagareda.)

Banana Crepe is located in one of the oldest buildings in Japantown that was constructed for a Japanese business. In 1906, Hokubei and Company opened at 248 Jackson Street. Marty Suzuki took over Banana Crepe in 2005, and now his son Jeff operates the business. (Photograph by James Nagareda.)

State of Grace (SOG) is one of Japantown's newer businesses. Opened in Japantown in 2002, it occupies the second floor of the Shanghai Building owned by the Dobashi family. For many years after the Shanghai Restaurant closed, the second floor was vacant. SOG owner Takahiro Kitamura is an excellent and well-respected tattoo artist. (Photograph by James Nagareda.)

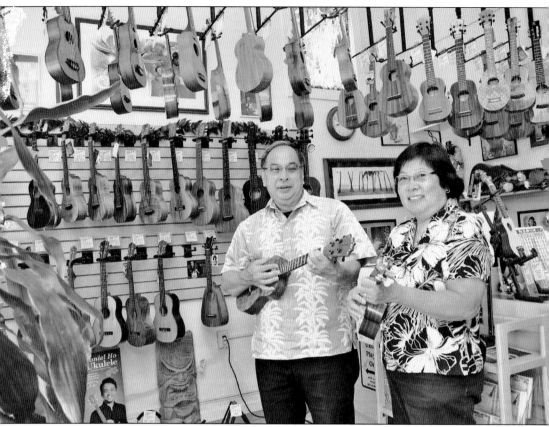

Smiley and Janet Kai opened their shop, Ukulele Source, in a small space that was previously occupied by Bill Furukawa Watch Repair. Since 2008, the Kais have been selling the finest ukuleles from Hawaii. Recently, the ukulele has seen a big resurgence in popularity. The Kais have produced and promoted Hawaiian music concerts, workshops, and private lessons with legends like Herb Ohta Jr., Ohta-San, George Kahumoku Jr., Keoki Kahumoku, and Nathan Aweau. They also give their time generously to the community. Ukulele Source is located at 599 North Fifth Street. (Photograph by James Nagareda.)

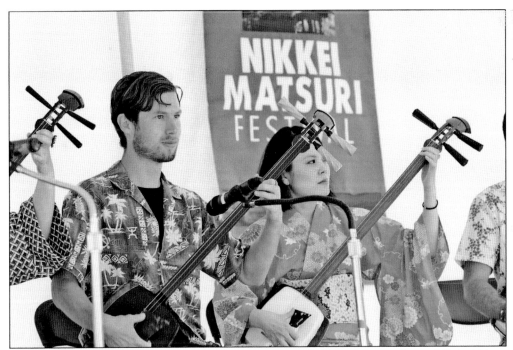

A group of shamisen players are performing at the Annual Nikkei Matsuri Festival. Kyle Abbott (far left) is the founder of Bachido, a resource for people that are interested in Tsugaru shamisen. Thousands of people attend this one-day event. (Photograph by James Nagareda.)

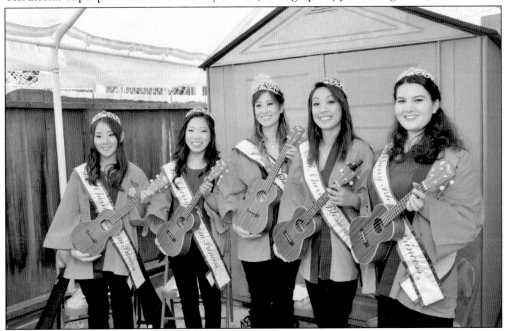

The San Francisco Cherry Blossom Queen and her court visit Nikkei Traditions during the San Jose Obon to get a quick ukulele lesson from Smiley Kai. From left to right are Kona Melissa Kawai, Nicole Harada, Samantha Beth Tsukiji, Kyla Kajioka, and Jan Mitsuko Cash. (Photograph by James Nagareda.)

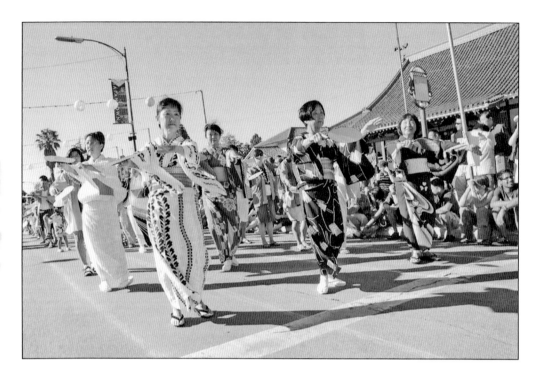

The *obon odori* dances are enjoyed by many people of all ages. San Jose Buddhist Church Betsuin has one of the largest obon odori with over 1,300 dancers participating. Some of the songs that are performed are songs that are based on old folk tales, while other songs are more current and upbeat. (Both photographs by James Nagareda.)

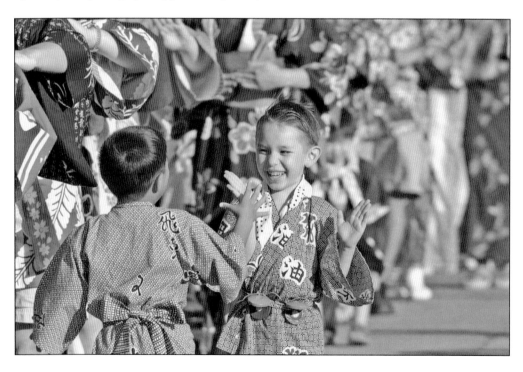

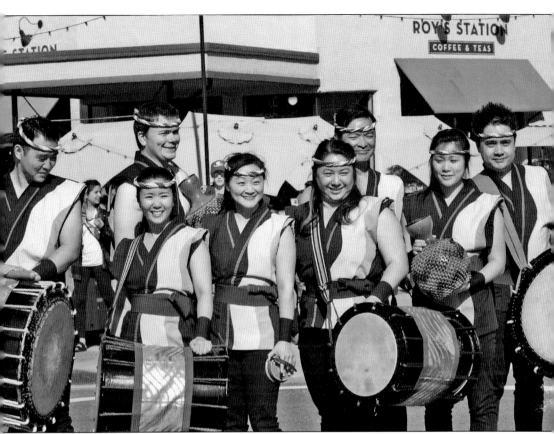

San Jose Taiko performers dedicate years of training in order to perform with the group. Here, a group of young taiko performers pose at the intersection of Fifth and Jackson Streets. From left to right are Byron Yamanaka, Alix Koyama (front), Warren Macdonald (back), Rina Chang, Kelli Wing, Franco Imperial (back), Vicky Phan, and Alex Hudson. (Photograph by James Nagareda.)

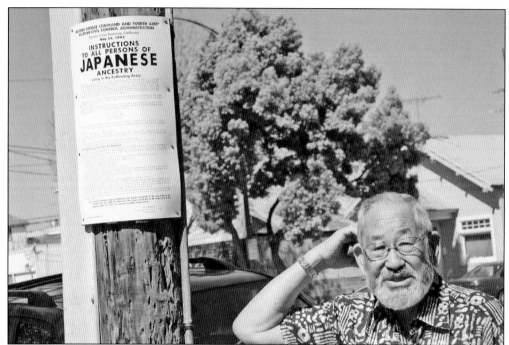

Jimi Yamaichi, pictured above, wears many hats. He is leading a group on a historical walking tour of Japantown. Here, he has stopped to talk about the Evacuation Notice that is posted on the telephone pole. After the attack on Pearl Harbor, Executive Order 9066 was issued, and thousands of people on the West Coast were torn away from their homes and put into desolate camps. Yamaichi was 19 years old when he was forced to leave San Jose. Below, Yamaichi had recreated an internment camp barrack in the Japanese American Museum of San Jose. Every detail was accurately reproduced, even the fact that young lumber was used in the construction. When this lumber dried out, it shrank and left gaps in the walls and floor where the wind and sand could enter the room. Some internees had to share a barrack. There was no privacy. (Both photographs by James Nagareda.)

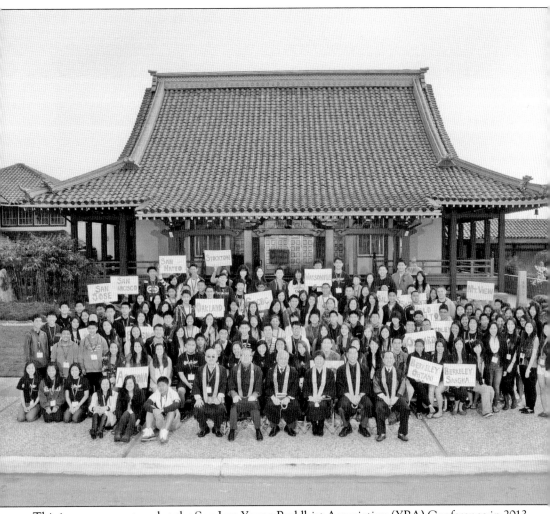

This image was captured at the San Jose Young Buddhist Association (YBA) Conference in 2013. The YBA was established in San Jose in 1946, lead by Eddie Yamaoka and then Tom Taketa with Hideo Nakamura as their advisor. The seated ministers from left to right are Rev. Orai Fujikawa, Rev. Jay Shinseki, Rev. Ken Fujimoto, Rev. Patti Oshita, Rev. Dean Koyama, and Rev. Shosei Hanayama. (Photograph by James Nagareda.)

Minato Restaurant opened in 1961 in a building that the Kogura family owns. The original owner, a Mr. Mogami, operated the restaurant for one year before falling ill. Mogami sold the restaurant to Ted Nakano, who ran the restaurant until 1980. The second floor above the restaurant was used for banquets until Bill Kogura opened Nikaku Japanese Arts in 1988. Mac Takeda bought the restaurant, then sold it to Gene and Jo Ann Yoneda in 1999. Minato Restaurant is the oldest Japanese Restaurant in San Jose. (Photograph by James Nagareda.)

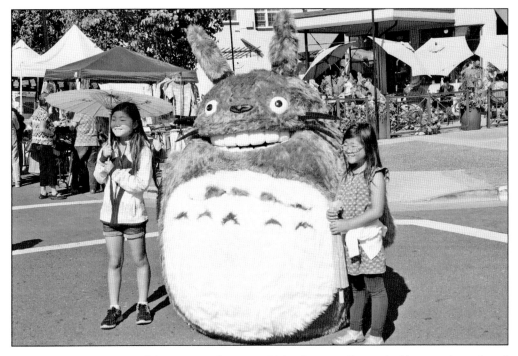

You never know what will happen at the next Nikkei Matsuri Festival. Above, a furry friend shows up to pose with children at the intersection of Fifth and Jackson Streets. Below, during another festival, a flash mob led by Sara Sakamoto perform a dance. Visible in the background are the koi (carp) that are ceremonially raised at the beginning of each Nikkei Matsuri. (Both photographs by James Nagareda.)

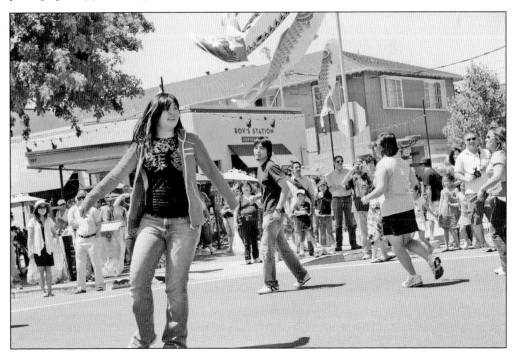

Lotus Preschool children play on one of the art pieces that is installed on Fifth Street. Japantown has received money for several different projects to beautify the area. There are historical benches, banner poles, decorative lighting, monuments, and public art all throughout Japantown. (Both photographs courtesy of Lotus Preschool.)

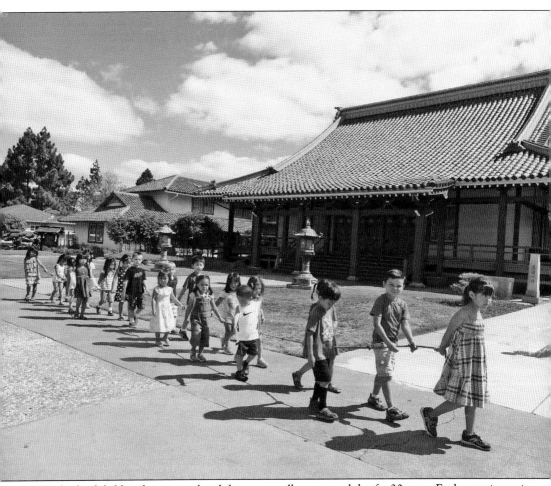

Hundreds of children have completed this same walk every weekday for 30 years. Each morning, rain or shine, the children at Lotus Preschool cross Fifth Street to attend a daily Buddhist ceremony at the temple. Since 1986, Lotus has served the community with Lynne Santo Yamaichi as the founder and director. These children are the future of Japantown. (Courtesy of Lotus Preschool.)

DISCOVER THOUSANDS OF LOCAL HISTORY BOOKS
FEATURING MILLIONS OF VINTAGE IMAGES

Arcadia Publishing, the leading local history publisher in the United States, is committed to making history accessible and meaningful through publishing books that celebrate and preserve the heritage of America's people and places.

Find more books like this at
www.arcadiapublishing.com

Search for your hometown history, your old stomping grounds, and even your favorite sports team.

Consistent with our mission to preserve history on a local level, this book was printed in South Carolina on American-made paper and manufactured entirely in the United States. Products carrying the accredited Forest Stewardship Council (FSC) label are printed on 100 percent FSC-certified paper.

MADE IN THE USA